Young-Girls in Echoland

Forerunners: Ideas First

Short books of thought-in-process scholarship, where intense analysis, questioning, and speculation take the lead

FROM THE UNIVERSITY OF MINNESOTA PRESS

(Continued on page 115)

Young-Girls in Echoland
#Theorizing Tiqqun

Heather Warren-Crow
and Andrea Jonsson

University of Minnesota Press

MINNEAPOLIS

LONDON

To explore further the art, theater, and popular media projects referenced in *Young-Girls in Echoland,* please visit the digital open-access edition of the book at https://manifold.umn.edu/projects/young-girls-in-echoland.

ISBN 978-1-5179-1302-1 (PB)
ISBN 978-1-4529-6679-3 (Ebook)
ISBN 978-1-4529-6702-8 (Manifold)

Published by the University of Minnesota Press, 2021
111 Third Avenue South, Suite 290
Minneapolis, MN 55401-2520
http://www.upress.umn.edu

 Available as a Manifold edition at manifold.umn.edu

The University of Minnesota is an equal-opportunity educator and employer.

"👨🏻‍🦲⚠️🔔💬🌍" ("Hush! Caution! Echoland!")

—JAMES JOYCE, *Finnegans Wake*

Contents

Introduction: Garbage-Core Is My Favorite Kind of Music

My favorite kind of music is garbage-core. Basically what you do is take a bunch of trash and throw it in a dumpster and then autotune the noise into a song.

—PROFESSOR_MEMES, *Battlelog Forum*

Basic Bitches

In artist Alex McQuilkin's video *Magic Moments (Preliminary Materials for a Theory of the Young-Girl)* (2013), a series of appropriated clips gives us Bambi-eyed models gazing at the camera, cut to a slow and breathy "Star-Spangled Banner." Many of the girls simultaneously open their eyes in invitation and withdraw from the viewer by moving backward into screen space. The effect is both revelatory and destabilizing. Eyelashes part. Hair moves forward in slow motion. Body moves backward, through the woods or across a beach or in a field of flowers. We think we know these girls; vulnerable, accessible, they could be one of Margaret Keane's big-eyed orphans, but with longer strides. Or better yet, the nice girl next door gifting us a pie to apologize in advance for tonight's kegger. We know their faces. They are white. They *really feel* us. They are above all open, except for those moments when faux lens flare or Lolita sunglasses obscure their features.

Seriously, these are some basic bitches. But we sort of love them.

The models, most of whom are selling clothes or perfume, are all adept at a kind of soft-focus seduction, and McQuilkin utilizes montage and slow motion to coax out the subliminal rhythms of such

sales(wo)manship. More pointedly, the video is carefully crafted to reveal the ways in which advertising produces an image of the girl consumer as the ideal citizen. The magic of these moments is in their use of girls cavorting in nature to conjure up a sense of freedom that can be applied to both citizenship and consumerism, supporting the emancipatory rhetoric of the United States as land of the free, of purchasing products as purchasing power, and of girlhood as the potential for social mobility. The pleasure these girls appear to take in dancing and romancing provides the exclamation point at the end of *girlpower!*—that conjoining of consumption and empowerment that invests the formerly marginalized figure of the girl with the capacity to bear society's hopes and dreams for a better future. McQuilkin's choice and manipulation of her source material demonstrate Sarah Gram's claim that while the girl as discursively constructed purports to operate in the "liminal space where consumption and emancipation begin to overlap," consumption is really "an alternative to liberation, rather than its realization."[1]

When we attend to the video's visual rhetoric, we notice that the models meet their sensuous manifest destiny in America's outdoor spaces. The video's soundtrack has a different spatial logic: minimally produced, with intimate vocals that include imperfections usually edited out of professional recordings, Mariela Napolitano's purposefully amateurish version of the national anthem sounds like a demo recorded in a small enclosure, reminding us of the (supposed) autonomy of girls in the private space of the bedroom.[2] Girlie bedroom culture developed, in large part, as a response to widespread anxieties about the vulnerability of girls in public spaces; with girls' behavior tightly regulated outside the home and often monitored by adults in domestic common areas, bedrooms have become places that can afford a certain agency. The free-to-be-meness of the bed-

1. Sarah Gram, "The Young-Girl and the Selfie," *Textual Relations* (blog), March 1, 2013, http://text-relations.blogspot.com/2013/03/the-young-girl-and-selfie.html.

2. Alex McQuilkin, pers. comm., July 19, 2017.

room musical performance and subsequent recording is suggested by Napolitano's grainy vocal timbre, slack articulation, and extra slow pace. I'll get there when and how I get there, Napolitano seems to say. However, while her rendition gives an overall impression of looseness that echoes the relaxation of the bodies we see spinning and smiling on screen, she is actually tightly metronomic in her rhythmic delivery, pointing to the contradiction at the heart of girlie bedroom culture: girls are both free and confined. Or perhaps, more negatively, freedom is an effect magicked through rhythmic patterns of control. McQuilkin's approach to editing the video—she insistently cuts on the beat—draws attention to the song's rigid triple meter and the unnaturalness of the models' coy performance of girlhood. "All the freedom of movement the Young-Girl enjoys in no way prevents her from being a *prisoner,* from manifesting, in every circumstance, the automatisms of the shut-in."[3]

Magic Moments is a response to a call, to a *provocation* (a word etymologically related to the Latin *vox,* or "voice").[4] This provocation is *Preliminary Materials for a Theory of the Young-Girl* (2012), a work of political philosophy originally published in French thirteen years prior by a group known as Tiqqun.[5] The collective retired their moniker eleven years before McQuilkin encountered Ariana Reines's English translation of *Preliminary Materials.* Between 1999 and the moment the artist saw a flash of its Revlon Cherries in the Snow cover at a university bookstore, the text was disseminated as an essay in Tiqqun's journal, also called *Tiqqun;* a separate book (also in French); an anonymously translated English version titled

3. Tiqqun, *Preliminary Materials for a Theory of the Young-Girl,* trans. Ariana Reines (Los Angeles, Calif.: Semiotext(e), 2012), 34.

4. *Etymonline,* s.v. "provocation (n.)," https://www.etymonline.com/word/provocation.

5. Their name, which is also the title of the journal in which they originally published their work, is a gallicization of part of the Hebrew phrase *tikkun olam,* which means "repair of the world." While the names of some members can be located online, we will not provide them, in an acknowledgment of the political statement made by pseudonymity.

Raw Materials for a Theory of the Young-Girl, still circulating as a PDF on the internet; an Italian translation in print; a Spanish translation currently in its second edition and sold on Amazon; and fragments quoted in blog posts, online articles, and YouTube videos. In fact, while Reines's high-profile print publication may have supercharged interest in *Preliminary Materials,* the text is most at home on the internet, pinged about by social media applications perhaps unforeseen by Tiqqun when they wrote their pre-Friendster/pre-Myspace *"trash theory."*[6]

It is not surprising that both Reines—a translator and poet whose visceral, acutely observed writing has been labeled girly, or rather, "Gurlesque"—and McQuilkin, whose videos address the emo-sexual dynamics of girl culture, were drawn to *Preliminary Materials.*[7] The text is a manifesto of sorts about the co-option of the figure of the Young-Girl by capitalism and her simultaneous capitulation to market forces. Attempting to expose the collusion of Empire, commodification, consumption, and girliness, *Preliminary Materials* identifies a problem but is arguably "thin on explaining how or why" the Young-Girl's "inescapable self-commodification took root," according to reviewer Cherilyn Parsons.[8] Regardless, *Preliminary Materials* continues to attract a large number of cultural practitioners, both those interested in the figure of the girl as subject matter and those who want to argue about the book's possible misogyny. McQuilkin, herself, falls in the first camp. *Preliminary Materials*'s characterization of the Young-Girl as a *"model citizen"* and a vector of capitalist oppression serves as a source of inspiration for her montage of patriotic girls-in-motion.[9]

6. Tiqqun, *Preliminary Materials,* 21.

7. Lara Glenum, "Welcome to the Gurlesque: The New Grrly, Grotesque, Burlesque Poetics," *Jacket Magazine* 40 (July 2010), http://jacketmagazine.com/40/glenum-gurlesque.shtml.

8. Cherilyn Parsons, "A Theory of the Young-Girl," *Truthdig,* November 22, 2013, https://www.truthdig.com/articles/a-theory-of-the-young-girl/.

9. Tiqqun, *Preliminary Materials,* 15.

Preliminary Materials combines Tiqqun's cutting observations with quotations from theory, literature, and women's fashion magazines to lay bare what they call "the anthropo*technical* project of Empire," that is, Empire's efforts to transform the feminized, infantilized subject into "the figure of the total and sovereign consumer" and then turn us all into the "non-being" that is the Young-Girl.[10] Tiqqun's explicit goal is to furnish weapons in a war against these forces of "Young-Girlization"—forces of infantilization and feminization that act on adolescents and adults, men and women (or rather, all genders).[11] Indeed, "the Young-Girl is obviously *not* a gendered concept," they maintain.[12] "The resplendent corporate advertising retiree"; "the urban single woman too obsessed with her consulting career to notice she's lost fifteen years of her life to it"; the "ultratrendy musclebound Marais homos"; the *beurette,* or Frenchwoman of North African heritage, "tarted up like a pornstar"; and the suburban "Americanized petit-bourgeoisie" all are Young-Girls now, reconfigured by capitalism.[13] In other words, Tiqqun's theory of the Young-Girl identifies a process of "Young-Girlist formatting" in which the skills of the supposedly ideal adolescent and the ideal woman—namely, consumption and seduction—have been instrumentalized and made prerequisites for subjectivity.[14] In the most succinct summary of their argument, Tiqqun write, "Hypostasized Youth and Femininity, abstracted and recoded into *Youthitude* and *Femininitude,* find themselves raised to the rank of ideal regulators of the integration of the Imperial citizenry. The figure of the Young-Girl combines these two determinations into one immediate, spontaneous, and perfectly desirable whole."[15]

Tiqqun's insistence on attaching attributes of gender and age to their allegedly generic conception of the neoliberal Western sub-

10. Tiqqun, 12, 24, 43.
11. Tiqqun, 21.
12. Tiqqun, 14.
13. Tiqqun, 14–15.
14. Tiqqun, 19.
15. Tiqqun, 16.

ject of late capitalism makes it challenging for many interlocutors to accept all of this argument at face value. Tiqqun are, after all, furthering a lineage of critique that associates femininity, especially youthful femininity, with commodities and consumption (a phenomenon discussed in detail in our book *Girlhood and the Plastic Image*). Marshall McLuhan, for example, had it out for midcentury Coca-Cola Girls chilling in print ads, and Siegfried Kracauer side-eyed the Tiller Girls, dance troupes whose precisely aligned high kicks inspired Busby Berkeley's choreography and delighted audiences during their heyday in the first half of the twentieth century.[16] Indeed, Tiqqun's claim that "the Young-Girl is an article of consumption, a device for maintaining order," could just as well be a quotation from Kracauer's "The Mass Ornament," an essay foundational for the fields of visual culture studies and media studies.[17] Here Kracauer details his understanding of these "products of American distraction factories" dancing together at the center of his oft-quoted critique of capitalism and modernity.[18] The Tiller Girls were British, not American, but that's a different story.

Tiqqun's Young-Girl is not only a product that is controlled and rigidly systematic, as Kracauer sees the Tiller Girls; she is also a consumer who is excessive, perverted. "The Young-Girl doesn't kiss you," Tiqqun sneer; "she drools over you through her teeth."[19] This "materialism of secretions," as Tiqqun so evocatively put it, reminds us of those poster children of the pathological consumer: screaming Beatlemaniac girls (allegedly) urinating on the auditorium floor.[20] "The Beatles was a case of watching females in excelsis," recalls musician Bob Geldof. "It's the old cliché, but you couldn't hear them for all the screaming. I remember looking down at the cinema floor

16. Heather Warren-Crow, *Girlhood and the Plastic Image* (Lebanon, N.H.: Dartmouth College Press, 2014), 66–68.

17. Tiqqun, *Preliminary Materials*, 114.

18. Siegfried Kracauer, "The Mass Ornament," in *The Mass Ornament: Weimar Essays* (Cambridge, Mass.: Harvard University Press, 1995), 75.

19. Tiqqun, *Preliminary Materials*, 39.

20. Tiqqun, 39.

and seeing these rivulets of piss in the aisles. The girls were liter-
ally pissing themselves with excitement. So what I associate most
with The Beatles is the smell of girls' urine."[21] Although the story
is hard to believe, it continues to provide a sensuously convincing
image of girliness as an emblem of the gross incontinence of the
consumer gone berserk. This idea persists despite scholarly efforts
to hear the fangirls' screams as "the first siren calls of a monumental
event in twentieth-century culture, in which gender roles and the
possibilities available to women were expanded and redefined."[22]
Beatlemania, according to this recuperative argument, is an expres-
sion of "liberation" and "empowerment."[23] Tiqqun would respond,
"The Young-Girl manages only to express the void, the living void,
seething and oozing, the humid void—until she vomits" (or, rather,
soils herself).[24]

The question whether collective girlie ejaculation is enabling
or instrumentalizing is at play in recent disputes about the Young-
Girliness of Femen, a controversial women's rights activist collective
formed in Ukraine but with its current headquarters in Paris. Les
Antigones, a French antifeminist group mobilized in opposition
to Femen, argues that the latter are "degrading" and "hysterical"
Young-Girls.[25] For Les Antigones, Femen's topless demonstra-
tions are exhibitionist, and posters made by monoprinting their
breasts and other supposedly perverse activities appeal to capital-
ist desire. By this argument, Femen's secretory blobs of paint on
poster board, sold to raise money for the group, are no more polit-

21. Qtd. in "Geldof's Grim Beatles Memory," *Express*, August 26, 2010,
https://www.express.co.uk/celebrity-news/195704/Geldof-s-grim-Beatles-
memory.

22. André Millard, *Beatlemania: Technology, Business, and Teen
Culture in Cold War America* (Baltimore: Johns Hopkins University Press,
2012), 134.

23. Millard, 134.

24. Tiqqun, *Preliminary Materials*, 126.

25. Les Antigones, "Femen or the rebellitude of the state," *Antigones*
(blog), July 23, 2013, https://lesantigones.fr/femen-ou-la-rebellitude-detat/.

ically emancipating than rivulets of piss in the aisles of an arena. Directly referencing Tiqqun's theory in their essay "Femininity, Fuel of Turbo-Capitalism," Les Antigones insist that the Young-Girl is late capitalism's "new model citizen," and Femen, they imply, are not revolutionaries but Young-Girls in excelsis.[26] Tensions between Les Antigones and Femen amplified when the designer of a French postage stamp claimed on Twitter that he modeled the face of Marianne, the anthropomorphized symbol of France, on Femen's Inna Shevchenko. Shevchenko responded to the controversy with "Femen is on French stamp. Now all homophobes, extremists, fascists will have to lick my ass when they want to send a letter."[27]

In stark contrast to Femen's cheeky embrace of analingus, Les Antigones tout the reproductive mother as the only proper female revolutionary figure for France. Surprisingly, perhaps, the aesthetic of Les Antigones' video "manifesto" is like that of McQuilkin's video critique of girlonationalism: a series of fresh-faced young Frenchwomen dressed in virginal white stand in a park, their hair blowing romantically in the breeze.[28] It's as if McQuilkin's ad girls tired of spinning on American beaches and emigrated to France, planting their feet in the grass among ornamental trees to defend their new motherland against a materialism of secretions. "The organic Young-Girl would thus become responsible, ecological, 'in solidarity,'" Tiqqun argue, "maternal, reasonable, 'natural,' respectful, more self-controlled than falsely liberated, in a word, fiendishly biopolitical. She would no longer mimic excess, but rather, moderation in all things."[29]

26. Les Antigones, "Femininity, Fuel of Turbo-Capitalism," *Antigones* (blog), October 12, 2013, https://lesantigones.fr/la-feminite-carburant-du-turbo-capitalisme/.

27. Qtd. in Angelique Chrisafis, "Femen Inspired Postage Stamp Angers French Right," *Guardian*, July 15, 2013, https://www.theguardian.com/world/2013/jul/15/femen-postage-stamp-france.

28. Les Antigones, "The Manifesto of the Antigones," YouTube video, 3:13, June 10, 2013, https://www.youtube.com/watch?v=_o-LLGpQiG4.

29. Tiqqun, *Preliminary Materials*, 20.

Preliminary Materials is a rare text. It serves as inspiration for antifeminists like Les Antigones and feminists like McQuilkin. It is quoted by gender studies scholar Catherine Driscoll as well as Jonny, a commenter on the men's rights website Return of Kings, which "aims to usher the return of the masculine man" as a challenge to our current "androgynous and politically-correct society that allows women to assert superiority and control over men."[30] Martial, a contributor to French men's rights website Neo-Masculin, writes a lengthy profile of the Young-Girl for readers taking the red pill.[31] Madison Velding-VanDam of the band the Wants claims it was one of two textual muses for their album *Container* (2020), while Kim Gordon credits it for shaping the lyrics for a collaborative album with Bill Nace.[32] In liner notes posted online, French director and writer Judith Cahen claims to have felt an urge somehow both "comical" and "virulent" moving her to create a radio piece in which sections of *Preliminary Materials* are read aloud by "rageful," "malicious" Young-Girls.[33] Musician and purveyor of "bubblegum

30. Catherine Driscoll, "The Mystique of the Young-Girl," *Feminist Theory* 14, no. 3 (2013): 285–94; jonny, September 30, 2014, comment on Thomas More, "The Manipulated Man, a Holy Bible of Red Pill Wisdom," *Return of Kings,* September 23, 2014, https://www.returnofkings.com/42941/the-manipulated-man-a-holy-bible-of-red-pill-wisdom; "About," *Return of Kings,* https://www.returnofkings.com/about.

31. Martial, "Principle Red Pill #20: Le principle of the Jeune Fille," *Neo-Masculin* (blog), January 11, 2018, https://neo-masculin.com/principe-pilule-rouge-20-principe-de-jeune-fille/. The term *red pill,* a reference to *The Matrix* (1999), is associated with the manosphere.

32. Qtd. in Sophie Williams, "The Wants on Recording Their Debut Album in a Shipping Container," *Guitar,* April 8, 2020, https://guitar.com/features/interviews/the-wants-playing-guitars-like-bass-recording-debut-album/; Emilie Friedlander, "What We're Reading: Emilie Friedlander," *Fader,* August 9, 2013, https://www.thefader.com/2013/08/09/what-were-reading-emilie-friedlander-3/.

33. Judith Cahen, "À nos corps défendants: Based on Preliminary Materials for a Theory of the Young-Girl, by Tiqqun," *Studylib,* https://studylibfr.com/doc/6796038/atelier-de-cr%C3%A9ation-radiophonique-%E2%80%93-dossier-de.

hyperreality" Hannah Diamond says the book changed her life.[34]
Fiona Duncan, in an interview with author Chris Kraus published
on the website for a clothing retailer, calls *Preliminary Materials*
"consciousness changing."[35] It attracts anarchists, communists,
and Tavi Gevinson, actress and former editor in chief of *Rookie
Magazine,* a now defunct online publication aimed at teen girls. It
is used to theorize Britney Spears's voice and "[Lena] Dunham's ass
(her vagina)"—the latter as a force that "troubles the impotence . . .
of empire," according to Clint Burnham.[36] "The Young-Girl, the va-
gina, the Internet is the 'inconsistent non-All,'" Burnham proposes,
cross-referencing Slavoj Žižek, Jacques Lacan, Tiqqun.[37]

Our *Young-Girls in Echoland: #Theorizing Tiqqun* functions as a
guide to the wide-ranging online/offline conversations surrounding
Tiqqun's self-proclaimed *"trash theory"* and proffers an argument
to explain the text's continuing influence on such a wide variety
of artists and writers, both professional and amateur. Importantly,
our focus for *Young-Girls in Echoland* is not whether *Preliminary
Materials* furthers an antifeminist or a feminist agenda. We stand
by our previous assertion that Tiqqun's polemic is both remarkably
perceptive and "a viciously phobic response to the feminization and
infantilization of the (male) subject as a result of consumption and
spectacular commodification."[38] We make this case in two previ-

34. Miles Bowe, "Hannah Diamond—'Attachment,'" *Stereogum,* April
24, 2014, https://www.stereogum.com/1678098/hannah-diamond-attach-
ment/news/; qtd. in Dominique Sisley, "The Books That Changed My Life,"
Dazed Digital, March 8, 2016, http://www.dazeddigital.com/artsandculture/
article/30259/1/the-books-that-changed-my-life.

35. Fiona Duncan, "I Love Dick on TV: Chris Kraus' Advice for a
Young-Girl," *SSense,* https://www.ssense.com/en-us/editorial/culture/i-
love-dick-on-tv.

36. Miriam Kongstad, "Hit Me Baby One More Time," https://sand-
berg.nl/thesis/miriam-kongstad; Clint Burnham, *Does the Internet Have
an Unconscious? Slavoj Žižek and Digital Culture* (New York: Bloomsbury,
2018), 62.

37. Burnham, *Does the Internet Have an Unconscious?*, 64.

38. Warren-Crow, *Girlhood and the Plastic Image,* 72.

ous publications, *Girlhood and the Plastic Image* and "Gossip Girl Goes to the Gallery: Bernadette Corporation and Digitextuality."[39] But *Young-Girls in Echoland* does something else entirely. Here we are interested in the role of the text's literary style—that is, its characteristic voice, tone, and form—in facilitating its own dissemination and appropriation, and the ways in which others have disseminated and appropriated the text in style and content. We argue that *Preliminary Materials*'s stylistic affordances invite public involvement in a highly active, variable, and noisy performance of political theorizing. This is political theory with a Tumblr fan page and an EDM beat posted to SoundCloud.[40]

Preliminary Materials has an unusual form for a work of theory. In fact, Tiqqun claim that it is not a work of theory at all. Not really. Instead, it is a "jumble of fragments," "materials accumulated by chance encounter."[41] "The choice to expose these elements in all their incompleteness, in their contingent original state, in their ordinary excess, knowing that if polished, hollowed out, and given a good trim they might together constitute an altogether presentable doctrine, we have chosen—just this once—*trash theory*."[42] Trash theory makes visible the disorderly *"process of deliberation"* concealed by conventional rhetoric.[43] Trash theory refuses to front. Trash theory is, according to Jen Kennedy, not exactly critical theory but its *"détournement,"* a strategy borrowed from *Internationale Situationniste,* Tiqqun's primary inspiration.[44] But even Situationist

39. Heather Warren-Crow, "Gossip Girl Goes to the Gallery: Bernadette Corporation and Digitextuality," *Performance Research: A Journal of the Performing Arts* 18, no. 5 (2013): 108–19.

40. *Theory of the Young-Girl* (blog), https://theoryoftheyoung-girl.tumblr.com/; "Tiqqun" (affect trance), "Preliminary Materials towards a Theory of the Young-Girl," 2013, https://soundcloud.com/affecttrance/feel001.

41. Tiqqun, *Preliminary Materials,* 20.

42. Tiqqun, 20–21.

43. Tiqqun, 21.

44. Jen Kennedy, "The Young-Girl in Theory," *Women and Performance: A Journal of Feminist Theory* 25, no. 2 (2015): 175.

Guy Debord's fragmentary *The Society of the Spectacle* (1967), *Preliminary Materials*'s most obvious forebear, seems like the sober companion to the meth binger that is Tiqqun's text.

Tiqqun do not provide a proper, well-built rhetorical framework for their notion of the Young-Girl. In the context of political theory, *Preliminary Materials* is a textual riot (or, for some, just a rowdy spring break). Tiqqun's text has a "collage style," Catherine Driscoll writes, admitting that she first thought it was a "feminist zine" in light of its use of juxtaposition and its mimicry of "the formal layout of girls' magazines."[45] Other commentators have instead noted *Preliminary Materials*'s relationship to a social media that had yet to come into its own. Amazon reviewer Rowland Akinduro describes the book as critiquing "the recycling of useless mantras (#liveauthentically, tumblr quotes, meaningless lyrics, #relatable)," all of which, aside from "meaningless lyrics," did not exist in 1999.[46] "The book alternates short passages, like tweets a decade early," explains Sasha Frere-Jones.[47] This "fragmented form" might make it "good toilet reading," jibes Toni, a reviewer on Goodreads, who hesitates to call it a book. It's "more like a peek inside the laboratory of a gang of anarchists experimenting with exotic explosives that sometimes fails and sometimes succeeds in conjuring up great potential."[48] As if hastily MacGyvered out of duct tape and what Reines terms "heterosexist *ressentiment*," it includes strings of quotations (printed in different fonts), usually without contextualization; unnecessary

45. Catherine Driscoll, "The Mystique of the Young-Girl," *Feminist Theory* 14, no. 3 (2013): 285.

46. Rowland Akinduro, "A Good Book in Your Collection," review of *Preliminary Materials for a Theory of the Young-Girl* by Tiqqun, Amazon, January 11, 2016, https://www.amazon.com/Preliminary-Materials-Young-Girl-Semiotext-Intervention/product-reviews/158435108X.

47. Qtd. in "What We're Reading: Summer Edition, Volume II," *New Yorker,* July 5, 2013, https://www.newyorker.com/books/page-turner/what-were-reading-summer-edition-volume-ii.

48. Toni, review of *Preliminary Materials for a Theory of the Young-Girl* by Tiqqun, Goodreads, July 25, 2012, http://www.goodreads.com/book/show/14367458-preliminary-materials-for-a-theory-of-the-young-girl.

italicization, boldface, and indentation; and scatological catchphras-
es, such as "The Young-Girl's ass is a global village," a cringeworthy
sound bite riffing off one by McLuhan, who declares that "the new
electronic interdependence recreates the world in the image of a
global village."[49] As Jean-Laurent Cassely, writing for French *Slate*,
imagines Tiqqun's sloganeering: "One/We/You could have made
t-shirts with Tiqqun's phrases and sell them at [the store] Colette"
("on aurait pu fabriquer des T-shirts avec les phrases de Tiqqun et
les vendre chez Colette").[50]

Preliminary Materials's hodgepodge of fonts ("Tiqqun's frag-
ments toggle through just about every legible font available in basic
Microsoft") serves several functions.[51] First, it is a nod to *Preliminary
Materials*'s rhetorical strategies of citation and bricolage, especially
Tiqqun's choice to appropriate text from women's fashion maga-
zines, which themselves usually combine multiple typefaces, sizes,
and weights. Second, as Adam Morris writes in a related point,

> the listless drift of the typeface contributes to Tiqqun's thesis that
> the Young-Girl's efforts at originality and authenticity are always
> limited to the tired-out templates of consumerism: she takes on and
> takes over these templates as her own, adopting them as original to
> her, when they are in fact facsimiles adopted and proliferated by all.[52]

Third, it highlights the text's pseudonymous authorship by bringing
to mind the design of a ransom note made out of differently sized

49. Ariana Reines, "Translator's Note," Tiqqun, *Preliminary Materials
for a Theory of the Young-Girl, Triple Canopy,* May 22, 2012, https://www.
canopycanopycanopy.com/contents/preliminary_materials_for_a_theory_
of_the_young_girl; Tiqqun, *Preliminary Materials*, 120; Marshall McLuhan,
The Gutenburg Galaxy (Toronto: University of Toronto Press, 2011), 36.

50. Jean-Laurent Cassely, "The Wearing of a Thong and Lowcut Jeans
in the Neoliberal Environment," *Slate France,* December 26, 2011, http://www.
slate.fr/story/47169/theorisation-string-jean-taille-basse-milieu-neoliberal.

51. Adam Morris, "Drone Warfare: Tiqqun, the Young-Girl and the
Imperialism of the Trivial," *Los Angeles Review of Books,* September 30,
2012, https://lareviewofbooks.org/article/drone-warfare-tiqqun-the-young-
girl-and-the-imperialism-of-the-trivial/.

52. Morris.

letters cut from magazines, a threat that is both menacing and darkly playful, evasive and in your face.

Such an approach to political philosophy—Is *Preliminary Materials* a game, or is it war? Is it written *for* women or *against* women?—makes Tiqqun's argument slippery, unstable. Indeed, Moira Weigel and Mal Ahern wager that the book is purposefully "undecidable": "Its self-ironizing speaker refuses to settle the question of whether the book is in fact sexist or just impersonating someone sexist in order to make its point."[53] This is, for Weigel and Ahern, ultimately a "conservative" and "patriarchal" strategy, for irony is an inadequate catalyst for transforming "hateful language into the basis of a sound critique."[54] Melissa Frost, a reviewer on Goodreads, sees the text as adopting a posture of hypocrisy, a strategy equivalent to saying "'not to be racist but . . .' then scan[ning] the room for POC before saying something CRAZY racist," something she finds "extremely alienating."[55] Blogger and user experience designer Mike Bulajewski characterizes the uncomfortable position of the reader as one of "deadlock":

> *Preliminary Materials for a Theory of the Young-Girl* is sexist in its effects, but to raise the charge of sexism is to silence the critique, which is a pro-capitalist move in its effects. There's no solution here, at least none that I can see. No matter how many times we repeat the magic word "raceclassgender," no synthesis is possible.[56]

Kennedy, on the other hand, describes the effect of Tiqqun's theory more positively and in poststructuralist terms: the text productive-

53. Moira Weigel and Mal Ahern, "Further Materials toward a Theory of the Man-Child," The *New Inquiry*, July 9, 2013, https://thenewinquiry.com/further-materials-toward-a-theory-of-the-man-child/.

54. Weigel and Ahern.

55. Melissa Frost, review of *Preliminary Materials for a Theory of the Young-Girl* by Tiqqun, Goodreads, December 1, 2014, https://www.goodreads.com/en/book/show/14367458-preliminary-materials-for-a-theory-of-the-young-girl.

56. Mike Bulajewski, "What Comes after the Man-Child?," *Meta Reader* (blog), July 22, 2013, http://www.metareader.org/post/what-comes-after-the-man-child.html.

ly "doubles back on itself, destabilizing its status as 'Theory' and foregrounding the mutability of its own meanings."[57] "A willingness to abandon the authority of interpretation is key to reading this deliberately schizophrenic text," Kennedy advises.[58]

But while the text's true meaning, or whether it has a true meaning, continues to be debated, its affect is almost unmistakable. It vibrates with revulsion. Reading it requires "ovaries of steel," in the words of one anonymous student blogger.[59] Case in point: "Deep down inside, the Young-Girl has the personality of a tampon" and "she's stupid and she reeks."[60] Evoking body shame and menstrual horror, such insults remind us of particularly brutal battles in an unsupervised middle school locker room—albeit battles fought by tweens who are well-read post-Marxists. A more grown-up but no less troubling characterization of the Young-Girl comes from reviewer Jeff Nagy: "the Young-Girl is less like a subject position than like the air that comes out of an impossibly silent window unit. Brooke Shields as Legionnaire's Disease on permanent tour."[61] The question for readers is whether such disgust is directed solely at the Spectacle under late capitalism or also at girliness itself. Perhaps the former slides into the latter following a similar path as that of their relationship to class politics, which McKenzie Wark observes across Tiqqun's oeuvre: "In the writings of Tiqqun, there is a slippage from revulsion against the party of the working class to revulsion at the working class itself."[62] In the case of *Preliminary Materials,* the pounding revulsion tends to polarize readers; the book is either a hotheaded but astute analysis of misogyny or a misogynistic shitshow.

57. Kennedy, "Young-Girl in Theory," 178.

58. Kennedy, 184.

59. This blog has disappeared, but we like the quotation enough to keep it without the citation.

60. Tiqqun, *Preliminary Materials,* 103, 85.

61. Jeff Nagy, "A Little Brooke of Visions," *BOMB,* September 26, 2012, https://bombmagazine.org/articles/a-little-brooke-of-visions/.

62. McKenzie Wark, *The Spectacle of Disintegration: Situationist Passages out of the 20th Century* (London: Verso, 2013), 196.

With Tiqqun's disgust in mind (and regardless of its target), we might approach the text's effects slightly differently. We wager that, for some readers of today, the book's "self-ironizing" speech performs a spectacular rhetorical contortion: whether or not the misogyny is feigned, the presence of such "hateful language" can be heard to signal a kind of sincerity—or, rather, a "hyper-sincerity"—a hallmark of the style of the "hyper-masculin[e]" political personae of Donald Trump and Vladimir Putin.[63] Tatiana Zhurzhenko, drawing on Elizabeth Markovits's critique of tell-it-like-it-is politics in *The Politics of Sincerity* (2008), argues that Trump's and Putin's offensive speech is often heard as a laudable willingness to say what others are thinking but too afraid to disclose. In this interpretative framework, the very harshness of Tiqqun's language performs sincerity, a lack of guile, a rejection of rhetoric, that overrides the text's heightened style and sidesteps the need to scrutinize the book's argument to determine whether its misogyny is put on or genuine. Whether or not these readers feel equally "girlphobic" (how we have elsewhere described *Preliminary Materials*), the text's willingness to articulate girlphobia suggests a hypersincerity appealing to those who might otherwise recoil at its popularity within anarchist and communist circles.[64]

Hypersincere or ironic, *Preliminary Materials* made its translator recoil. As Reines writes of her experience translating the work, it "was like being made to vomit up my first two books, eat the vomit, vomit again, etc., then pour the mess into ice trays and freeze it, and then pour liquor over the cubes." The book "infect[ed] her," left her "shitting rivers." She "absorbed the text, and passed it through [her] person." Reading the final product, though, she concludes that she

63. Weigel and Ahern, "Further Materials toward a Theory of the Man-Child"; Tatiana Zhurzhenko, "The Importance of Being Earnest: Putin, Trump and the Politics of Sincerity," *Eurozine*, February 26, 2018, https://www.eurozine.com/importance-earnest-putin-trump-politics-sincerity/.

64. Warren-Crow, *Girlhood and the Plastic Image*, 73.

"feel[s] in effortless agreement with most of it." "I mean, if we were cowboys," she clarifies, "me and this book would be on the same side, fighting the sheriff, but totally not besties."[65]

Reines's horse-bound solidarity is not the point of this book. But her nausea might be. "Tiqqun's writing is viscerally oral," notes Jennifer Boyd. "Each phrase is spat out, bitten, or said through gritted teeth. . . . This sneer emits from the pages of Theory of the Young-Girl as if a noxious gas."[66] In her feminist reclamation of *Preliminary Materials,* Kennedy characterizes the "affective, sickening, disruptive dimension of reading this text" as a result of Tiqqun's weaponizing of the Young-Girl, which allows the girl to be not only a victim but also an irritant, an agent, a provocateur.[67]

Disgust is a particularly affecting and disruptive mode of bodily participation, and *Preliminary Materials,* through content and style, is an expertly composed invitation to participate. Our *Young-Girls in Echoland* is concerned with the participatory aesthetics of the theory of the Young-Girl. More accurately, it is concerned with the participatory aesthetics of *theories* of the Young-Girl—the one offered by Tiqqun as well as those developed by their many advocates, enemies, and adaptors. The Young-Girl is not only a conceptual persona constructed by Tiqqun but also a dialogue between the French manifesto and various translators, artists, poets, students, scholars, teachers, bloggers, activists, and other interlocutors. Indeed, the Young-Girl who has yet to be thoroughly discussed is this multimodal conversation writ large, theories that both exceed the bounds of *Preliminary Materials* and respond to a call from within the text's stylistic parameters. This larger collection of theories has much to say about the Young-Girl as a contested figure of discourse, yes, but also about *"trash theory"* as a participatory multimedia performance

65. Reines, "Translator's Note."

66. Jennifer Boyd, "A Theory for the Strange-Girl: Raw Red Text," *Country Music,* August 2017, https://www.country-music.co/wp-content/uploads/2017/08/CM2-JenniferBoyd.pdf.

67. Kennedy, "Young-Girl in Theory," 180.

and about the peculiar affordances of text in our age of social networks. *Young-Girls in Echoland* documents the images, words, and sounds of trash discourse in Anglophone and Francophone contexts, much of which would otherwise disappear as links break, relevant blogs go 404 not found or *Erreur 404 page non trouvée,* and galleries and theaters close.

Hush! Caution! Echoland!

"Tiqqun's writing is viscerally oral," we have already heard. It is also viscerally aural. "Listen," they demand. "The Young-Girl is obviously *not* a gendered concept."[68] And later: the Young-Girl embodies "chatter, curiosity, equivocation, hearsay."[69] Theories of the Young-Girl are full of noise—which comes from an Old French word meaning "din, disturbance, uproar, or brawl" and, before that, the Latin word *nausea,* or "seasickness" (Reines felt like she had to vomit and then consume it, and neomasculine misogynists Ralf and Martial call the Young-Girl "a subhuman vomited by the society of consumption and narcissism" ["Le sous-être vomi par la société de consommation et de narcissisme qui est la nôtre"]).[70] *Noise* can also mean "rumor," "hearsay." To noise about is to spread gossip. #Girltalk. *Gossip Girl.* Materialism of secretions. "Background noise," Michel Serres reminds us, is "the residue and the cesspool of our messages" as well as "our perennial sustenance."[71] Noise, nausea, uproar, chatter, rumor, hearsay, gossip—"The Young-Girl is idle talk substantiated."[72] Barf. According to Jeff Nagy, in a charac-

68. Tiqqun, *Preliminary Materials,* 14.

69. Tiqqun, 25.

70. *Etymonline,* s.v. "noise (n.)," https://www.etymonline.com/word/noise; Bistrot des Gentilshommes, "Inside the Brain of Young Girls: The Hamster—Lumière Rouge #3," YouTube video, 29:45, April 17, 2019, https://www.youtube.com/watch?v=oAqtON3QNGY.

71. Michel Serres, *Genesis* (Ann Arbor: University of Michigan Press, 2005), 7.

72. Nina Power, "She's Just Not That into You," *Radical Philosophy* 177,

teristically colorful and insensitive turn of phrase, "the combination of [*Preliminary Materials*'s] constant nauseated tone and inverted self-help structure can make it feel like a succession of motivational posters for the use of bulimics."[73]

"The Young-Girl's laughter rings with the desolation of night-clubs."[74] A nightclub or maybe Cabaret Voltaire, girls' night. "Like a Dada poem," Kennedy suggests, "this is a performative collage that often begs to be read out loud, variously inflected with Valley Girl syntax, academic stiffness, and activist hubris."[75] Note that, like, Valley Girl slang, or Valspeak, requires some contortions of the mandible. As fourteen-year-old Moon Unit Zappa guides interviewer Mike Douglas in the early 1980s, "you must think severe underbite, OK? And think of the muscles straining and the jaw being like pulled out."[76] Douglas's face moves awkwardly as he says "barf out! I am sure." One of the most well-known phrases in the Valspeak lexicon is "gag me with a spoon," a reference to bulimia. "Valley Girls are lurking everywhere," Zappa says expertly. "You have to think of slurring the . . . the words . . . the the the the Rs and just everything, make it seem as if it's rolling off your tongue."[77] The French word *préliminaires,* which is the first section title of Tiqqun's manifesto (and not in the book's title, as Reines's translation of *Premiers Matériaux pour une Théorie de la Jeune-Fille* might suggest), connotes sexual foreplay, which may indeed include pillow talk, and the French word for "pillow," *l'oreiller,* is etymologically related to the word for "ear." What Mareile Pfannebecker and J. A. Smith call the "mix tape postmodernism" of *Preliminary Materials*'s rhetorical style—

no. 1 (2013), https://www.radicalphilosophy.com/reviews/individual-re-views/rp177-shes-just-not-that-into-you.

73. Nagy, "A Little Brooke of Visions."

74. Tiqqun, *Preliminary Materials,* 40.

75. Kennedy, "Young-Girl in Theory," 185.

76. Terrence Thompson, "Moon Unit Zappa Full Show," YouTube video, 6:40, December 7, 2015, https://www.youtube.com/watch?v=mO-HHwwqAN5s.

77. Thompson.

in reference to the text's strategy of bricolage—can be taken more literally as an indication of the text's aural address.[78]

Our approach to writing about Young-Girls is driven not by close reading of texts and images but by *close listening*: an attention to rhythm, vibration, melody, harmony, refrain, and orality. We want to understand the temporal and timbral patterns that give shape to *Preliminary Materials* and the pop theory that continues to develop in response. Situating our listening ears amid what has proven to be a voluble debate, our efforts to hear theories of the Young-Girl as contested but participatory phenomena open up new ways of considering feminine adolescence in/as public discourse.

Indeed, theories of the Young-Girl should be considered spaces for collective listening—as auditory spaces (also known as acoustic or audio spaces), as articulated by McLuhan. This is not to say that the texts and works of visual art we discuss can't be seen. Instead, as McLuhan clarifies,

> any pattern in which the components co-exist without direct, lineal hook-up or connection, creating a field of simultaneous relations, is auditory, even though some of its aspects can be seen. The items of news and advertising that exist under a newspaper dateline are interrelated only by that dateline. They have no interconnection of logic or statement. Yet they form a mosaic of corporate image whose parts are interpenetrating. . . . It is a kind of orchestral, resonating unity, not the unity of logical discourse.[79]

While the various art projects, Tumblr pages, and translations of *Preliminary Materials* that make up theories of the Young-Girl have stronger interconnections than a collection of articles on the page of a newspaper, they hardly present the lineal logic McLuhan associates with visual space. Instead, they are, collectively, like Tiqqun's

78. Mareile Pfannebecker and J. A. Smith, *Work Want Work: Labor and Desire at the End of Capitalism* (London: Zed Books, 2020), 89.

79. Marshall McLuhan, "The Agenbite of Outwit," *McLuhan Studies*, no. 2 (1996), http://projects.chass.utoronto.ca/mcluhan-studies/vl_iss2/1_2art6.htm.

theory: an "orchestral, resonating unity" composed of "materials accumulated by chance encounter."[80] "Orchestral," or maybe just musical, as the former is an improperly highbrow metaphor for what Goodreads reviewer Hadrian likens to "the deranged manifesto of some 'red-pilled' idiot on reddit."[81] More generously, we could say that *Preliminary Materials* is loopy and invites a mode of collaborative theorizing that echoes its own loopy configuration ("Loops repeat and revise," Kathleen Gough reminds us).[82]

The sheer number of definitions of the Young-Girl that Tiqqun provide gives us, as readers, the feeling that she is everything and nothing, as apparently boundaryless as cyberspace, where much of the theory of the Young-Girl so effectively circulates. After all, the internet has, for many, fulfilled the destiny that McLuhan ascribes to television—more immersive, multicentered, and participatory than the electronic medium on which McLuhan focuses much of his scholarly concern. In other words, the internet, and especially social media, has out-global-villaged television, outplayed the "tribal drums" McLuhan hears resounding in the age of electronic media: "The world is now like a continually sounding tribal drum where everybody gets the message all the time. A princess gets married in England and boom boom boom! go the drums. We all hear about it. An earthquake in North Africa, a Hollywood star gets drunk—away go the drums again," McLuhan proclaims in a CBC television appearance from 1960.[83] Although gendered metaphors are not common in his writings after *The Mechanical Bride*, he does snidely describe the global village as "a sort of Ann Landers column

80. McLuhan; Tiqqun, *Preliminary Materials*, 20.

81. Hadrian, review of *Preliminary Materials for a Theory of the Young-Girl*, Goodreads, https://www.goodreads.com/en/book/show/14367458-preliminary-materials-for-a-theory-of-the-young-girl.

82. Kathleen M. Gough, "The Art of the Loop, Analogy, Aurality, History, Performance," *Drama Review* 60, no. 1 (2016): 94.

83. healthcarefuture, "Marshall McLuhan—The World Is a Global Village (CBC TV)," YouTube video, 8:44, March 24, 2009, https://www.youtube.com/watch?v=HeDnPP6ntic.

written larger," inviting a connection between his earlier critique of the mechanical brides of advertising and his later distaste for the feminized chitchat of both the advice column and the electronic global village.[84] Indeed, while McLuhan is often believed to be the global village's unqualified champion, he is actually ambivalent at best, as he clearly does not want to hear tribal drums or news stories about African earthquakes, the goings-on of English princesses, and Hollywood blotto. Quip Tiqqun, "the Young-Girl's ass is a global village."[85]

McLuhan knows little substantive about the villagers whose presumed oral-aural sensory experiences inspire some of his most well-known ideas. Ross Brown explains, writing specifically about an article McLuhan coauthored with Edmund Carpenter, that the concept of acoustic space "propose[s] a theoretical acoustemology that draws casually on exotic tropes of generic non-Western mysticism."[86] More damningly, Ginger Nolan details that McLuhan's most signature phrase ("the global village") was written "in reference to various devices of British colonial and neocolonial power"; McLuhan supports his concept by citing scholarship on "Britain's brutal villagization scheme in Kenya in the 1950s."[87] McLuhan's media theory has no value in explaining the indigenous worldviews of the Inuit, whom Carpenter and McLuhan reference in their article, or the sensoria of Kenyan people of the early to mid-twentieth century.

The theory of acoustic space, despite (or because of) the concept's colonialist foundations, can still be a useful framework for listening to *Preliminary Materials* as it reverberates within the

84. Paul Benedetti and Nancy DeHart, eds., *On McLuhan: Forward through the Rearview Mirror* (Scarborough, Ont.: Prentice-Hall Canada, 1997), 40.

85. Tiqqun, *Preliminary Materials,* 120.

86. Ross Brown, *Sound Effect: The Theatre We Hear* (New York: Bloomsbury, 2020), 133.

87. Ginger Nolan, *The Neocolonialism of the Global Village* (Minneapolis: University of Minnesota Press, 2018), 1, 2.

space of Anglophone and Francophone digital communication.[88] We are interested in separating *McLuhanisme* from its primitivist matrix, employing aspects of his acoustemology to describe the stylistic expression of Tiqqun's theory of the Young-Girl as well as its transmission, appropriation, and adaptation over the internet. "A bell is to audio space what a polished surface is to a visual space—a mirror," McLuhan and Carpenter proclaim, in a reference to James Joyce's *Finnegans Wake* (1939), central to McLuhan's thinking on the potential of acoustic space on the printed page. "The bell and/or the belle is/are simultaneously all things. The age of the electronic and the simultaneous is to be an age of bell(es)."[89]

In swapping out the visual for the audio, the mirror for the bell(e), we swap out Narcissus for Echo (despite the fact that McLuhan gives Narcissus pride of place in his theory of the pathologies of the electronic age). A nymph cursed to repeat the words of others, and only the last few words of an utterance at that, Echo's tragic lot is to become a technology of sonic reproduction. She is spurned by Narcissus, and her body withers to bone and finally stone; however, her echoing voice continues on. What if such resounding life were not a complete disaster? Understanding her fate more positively, as some kind of power, however compromised, we could say that

88. The Canadian provenance of the theory of auditory space suggests its particular applicability to late twentieth-/early twenty-first-century Anglophone and Francophone milieux, given Canada's dual national languages. More specifically, McLuhan had a famously enthusiastic reception in France, which saw the "McLuhanization of French intellectuals and media workers interested and operating in creative communications and media environments," in part through coverage by Québécois journalists in the 1960s and 1970s and the influence of McLuhanisme among French theorists of the 1980s and 1990s who function as direct forebears of Tiqqun, such as Jean Baudrillard and Paul Virilio. Gary Genosko, *McLuhan and Baudrillard: Masters of Implosion* (New York: Routledge, 1999), 1.

89. Edmund Carpenter and Marshall McLuhan, "Television Murders Telephony," in *Verbi-Voco-Visual Explorations 8: Studies in Culture and Communication,* ed. Edmund Carpenter and Marshall McLuhan (Eugene, Oreg.: WIPF and Stock, 2016), 61.

"Echo can disseminate," while her notoriously self-obsessed non-lover "Narcissus is fixed."[90] Gayatri Spivak, whose astute analysis of Ovid's Echo and Narcissus we borrow here, closes her essay with a quotation from *Finnegans Wake*: "Hush! Caution! Echoland!"[91]

The idea of acoustic space, as explained through the examples of the newspaper and *Finnegans Wake,* underscores the insistent multimodality of some kinds of typographic text, an insight necessary for an analysis of *Preliminary Materials* as both sound and print and of other, net-based theories of the Young-Girl as both oral and textual (claims that will be explained in greater detail later in this book). What is useful in McLuhan's patriarchal and colonial boom boom boom! is the close relation between the princess (or any girled individual), the rhythmic musicality of the media environment, and the vibrational impact of certain types of textual communication, especially when amplified by artists wishing us to feel, *really feel,* the resonant affectivity of language. There are no tribal drums in this new scenario. Instead, it's a more relevant instrument, the gum in Rafaela Lopez and Georgia René-Worms's performance *Bubble Boom, the Jeune-Fille said: a bit of bubble and a little bit of boom* (2015):

La Jeune-Fille is a Concept
La Jeune-Fille is a deviation
bubble, bubble gum, pink bubble gum
Makes **boom**[92]

The whole poem was printed on pink paper, folded and sealed with a gold sticker, and made available on a shelf in the gallery. Like Tiqqun (and McLuhan), the artists play with fonts and the text's

90. Gayatri Chakravorty Spivak, "Echo," *New Literary History* 24, no. 1 (1993): 38.

91. Spivak, 39.

92. Rafaela Lopez and Georgia René-Worms, "Bubble Boom, the Jeune-Fille said: a bit of bubble and a little bit of boom," https://rafaelal-opez.net/Bubble-Boom.

arrangement on the page, giving a sense of rhythm and amplitude to conduct the reader's inner speech.

Our investigation of theories of the Young-Girl leads us, again and again, to rhythm, a concept more frequently employed in the study of poetry than of political theory. Rhythm is notoriously difficult to define; here we are using the most capacious understanding possible: an arrangement that articulates a changing relationship between pure repetition and variation (or, according to Henri Lefebvre's more abstract definition, "movements and differences within repetition").[93] This notion of rhythm can be applied across modalities and scales, from the repetitions and variations of an individual text to the coordination of the text's rhythms with vibrations in mediatized milieux in our age of bell(es). Indeed, in consideration of what Ben Glaser calls "rhythm's scalar power," we argue that *Preliminary Materials* is a successful pop theory phenomenon because its rhythms resonate with those of the digital media environment that sustains much of the critical commentary (whether textual, as in book reviews published in web periodicals, or visual, as in the image-oriented Tumblr "fanpage" dedicated to Tiqqun's theory).[94] While our definition of rhythm may be frustratingly broad, we agree with David Nowell Smith's insistence that, ultimately, "it is not a question of determining that rhythm 'is' *x*, but rather of formulating what it is that rhythm *calls,* calls *for,* and calls *to*—what it allows us to think, what it demands that we think."[95] The rhythm of *Preliminary Materials* is, among many things, a meta-commentary on rhythm itself, in that it allows us to think of rhythm as a kind of call, a call that is always already social

93. Henri Lefebvre, *Rhythmanalysis: Space, Time and Everyday Life* (London: Continuum, 2004), 90.

94. Ben Glaser, introduction to *Critical Rhythm: The Poetics of a Literary Life Form,* ed. Ben Glaser and Jonathan Culler (New York: Fordham University Press, 2019), 2; *theoryoftheyoung-girl* (blog), https://theoryoftheyoung-girl.tumblr.com/.

95. David Nowell Smith, "What Is Called Rhythm?," in Glaser and Culler, *Critical Rhythm,* 43–44.

and mediated. *Preliminary Materials* also demands that we think of rhythm as political and, in turn, politicizes the rhythms (metered pulses as well as less tractable patterns) that ripple throughout its media networks.

Preliminary Materials seems remarkably ahead of its time in its applicability to social media. Commentators attribute its contemporary relevance either to readers' *extension* of Tiqqun's "analysis to encompass developments in social media that have taken place since the book's original publication: the direct facial and self-valorizing imperatives of Facebook, the endless memetic re-postings of tumblr, fashion blogs, and so on," or to the text's almost *psychic* perspicacity.[96] Importantly, though, the headquarters of the journal *Tiqqun,* where the text was originally published, is identified on the back of the journal as Paris, and France was once "the most wired country in the world."[97] From the early 1980s to 2012, France had Minitel, a national networked communication service developed prior to the World Wide Web. The French government gave Minitel terminals away for free and required the use of them for certain bureaucratic activities, resulting in mass familiarity with chat rooms, networked games, and other aspects of social media well in advance of other countries. Pornographic chat rooms were advertised on posters in public spaces, broadening the country's awareness of social media. By the time *Preliminary Materials* was published in 1999, France had been conducting business and having dirty fun on Minitel for almost twenty years. With this in mind, it is not surprising that *Preliminary Materials* feels preternaturally linked into the rhythms of social media of the twenty-first century, and that the internet would feel like a natural home for various Young-Girls of the world.

That said, the response to *Preliminary Materials* is not solely a networked phenomenon, as already indicated by our exegesis of

96. Power, "She's Just Not That into You."

97. Julien Meilland and Kevin Driscoll, *Minitel: Welcome to the Internet* (Cambridge, Mass.: MIT Press, 2017), 1. See this book for a detailed account of the development and promotion of Minitel.

McQuilkin's *Magic Moments,* which has been exhibited at Spring/ Break art fair in New York City, Microscope Gallery in Brooklyn, and Plymouth Rock gallery in Zurich.[98] One common form of engagement with the text involves reading it aloud as part of theater pieces, performance art, and radio projects. Examples include *Death and the Jeune-Fille* (2010), a play by the Québec City–based theater group Le Bureau de L'APA described as "a kind of guided reading"; Lopez and René-Worms's 2015 performance piece at London's Bosse and Baum gallery, where participants walked around chewing gum and whispering Tiqqun quotations into the audience's ears; a radio play written by Judith Cahen and directed by Anne-Pascale Desvignes (2007); Nesrine Khodr's video-based performance *Tahrïk* (2018), in which the Lebanese artist reads part of *Preliminary Materials* translated into Modern Standard Arabic; a reading group organized by Canadian gallery Griffin Art Projects in 2018 to develop "new meanings and nuanced interpretations of artmaking and objecthood through the figure of the 'Young-Girl'"; and the Young Girl Reading Group (YGRG, 2013–), the moniker for a series of performance events created as "a space for conversation."[99]

Theories of the Young-Girl are a conversation. About the Young-Girl, about young girls, about capitalism and advertising, about pop culture and theory and political engagement and technology, about what words mean and how they sound. For our book, we listened to this conversation for its timbres, rhythms, energies, and feelings, treating the discussion as a soundscape of the Young-Girl as post-internet discourse. Post-internet generally refers to a kind of art heavily influenced by the aesthetics of social

98. Alex McQuilkin, pers. comm., May 31, 2020.
99. Le Bureau de L'APA, "Death and the Jeune-Fille," https://www. bureaudelapa.com/en/projetsliste-apa.php; Griffin Art Projects, "Reading Group: Performativity as Technique of the Self," December 8, 2018, http:// griffinartprojects.ca/pastevents/2018/performativity-reading/; Dorota Halina Gawęda, Eglė Kulbokaitė, and Lucie Kolb, "The Young-Girl Reading Group: An Email Interview," *Brand-New-Life,* June 24, 2016, http://brand-new-life.org/b-n-l/ygrg/.

media and other web-based forms of vernacular cultural production. Unlike internet art, which is disseminated only on the internet, post-internet art can "'jump' from screen to gallery wall or space."[100] Similarly, theories of the Young-Girl are excellent jumpers, moving from the internet to the bookstore to the gallery to the stage and back again. As Nicholas Thoburn notes, the "media field" that is the "English language reception of Tiqqun" identifies the collective "as one of the first born-post-digital phenomena in communist publishing, with print, online, and e-pub versions interlaced."[101] Whether *Preliminary Materials* is framed as communist, anarcho-communist, or simply anticapitalist, theories of the Young-Girl are interlaced and multimodal post-internet phenomena. These theories come into their own through movement, iteration, and transduction. We are not attempting to critique this conversation as much as diagram its waveform.

The movement of theories of the Young-Girl writ large, in both real space and networked environments, has something in common with the "conversational style of written exchange" Charlotte Frost identifies as central to communication through LISTSERVs:

> One person presents an idea or argument; others respond, to varying degrees, at different times, and, in so doing, effectively rewrite the original text through their own paraphrasing, insertions and interpretation. As a result, a sort of re-versioning relay occurs where ideas are analysed and extended through the continuous writing and rewriting. There tends to be no winning of an argument or final definitive piece of text (even if some participants might claim otherwise), because this is a system in which value is mainly derived from passing an idea back and forth as opposed to holding it still.[102]

100. mitsn437, "What Is Net and Post-Internet Art," *Maps Territories and Location Art, Now and Then* (blog), September 17, 2014, https://mitsn437.wordpress.com/2014/09/17/what-is-post-internet-art/.

101. Nicholas Thoburn, *Anti-Book: On the Art and Politics of Radical Publishing* (Minneapolis: University of Minnesota Press, 2016), 204.

102. Charlotte Frost, *Art Criticism Online: A History* (Canterbury, U.K.: Gylphi, 2019), 106–7.

This "call-and-response model" is referenced frequently throughout Frost's *Art Criticism Online: A History,* which investigates the expanded field of writing about art made possible through digitextuality.[103] Frost effectively deinstitutionalizes ideas about what counts as art criticism through an examination of social media conversations, LISTSERV dynamics, bulletin board discussions, and "'critico-contextual' objects, or, rather, creative projects which expand the contextual and critical field of the arts."[104] Our *Young-Girls in Echoland* is likewise concerned with popular and sometimes populist formats of "collective criticality," the "call-and-response model" governing, in our case, theories of the Young-Girl and the function of creative practice as a mode of inquiry.[105] Our interest, though, is in diversifying not art criticism and art history but philosophy and theory.

In contradistinction to other academic treatments of *Preliminary Materials,* including our own *Girlhood and the Plastic Image* and "Gossip Girl Goes to the Gallery," we have chosen to explain the content of the text principally through an analysis of its stylistic affordances mimicked and exaggerated by interlocutors. Other than what has been summarized in this introduction, Tiqqun's theory of the Young-Girl emerges in this book through our analyses of theories created in direct response. In other words, you will hear the voice of Narcissus primarily through Echo's fragmentary repetitions. Those who want to read about *Preliminary Materials* in isolation, in relation to Tiqqun's other work or, more broadly, to avowedly post-Situationist cultural practice, should look elsewhere. Moreover, as you might assume, our aim is not to produce an incisive reading of Tiqqun's argument but to study that particular text's ability to compel readers, and their compulsion to respond through visual art, creative writing, theater, performance art, and popular media. Note that like Echo's reiterative appeals, which

103. Frost, 109.
104. Frost, 138.
105. Frost, 106, 109.

convey the rejected nymph's love for Narcissus even though their source material does not express love for her at all (a disjunct that Ovid cleverly makes known to his readers), even simple repetitions of parts of *Preliminary Materials* can alter the initial, contextually derived meaning dramatically.[106] Or rather, like Narcissus's generic utterances, *Preliminary Materials* is semantically unstable. Perhaps the real fucking tragicomedy is not the girl doomed to fragment and repeat. Instead, it's the boy whose originating speech has no secure meaning at all, whose words are so easily spoken by another in such radically conflicting ways.[107]

Of course, *Preliminary Materials* is a written text and thus not speech in the literal sense. But the text is audible nonetheless. While our acoustemological method does not exclusively concern itself with sound as conventionally understood—especially in the following chapter on iteration—it does mark an approach to textual analysis as a kind of listening to a resonating musical unity across time and space. Music's defining feature, according to scholar of music cognition Elizabeth Hellmuth Margulis, is repetition. As she explains the astonishing speech-to-sound illusion discovered by psychologist Diana Deutsch, when a section of a recorded utterance is repeated multiple times, the listener henceforth hears that segment in the recording *musically,* "as if the speaker has broken into song, Disney-style," cognitive autotuning. Margulis summarizes the importance of the phenomenon:

> This illusion demonstrates what it means to hear something musically. The "musicalisation" shifts your attention from the meaning

106. For example, in one translation, Narcissus spits out, "Take your hands off! I'll die before I let you have me!" and Echo responds, "Have me!" See Almut-Barbara Renger, "Narrating Narcissus, Reflecting Cognition: Illusion, Disillusion, 'Self-Cognition' and 'Love as Passion' in Ovid and Beyond," *Frontiers of Narrative Studies* 3, no. 1 (2017), https://www.degruyter.com/document/doi/10.1515/fns-2017-0002/html.

107. In a reading of Ovid's myth, Claire Nouvet understands the "Disaster of Narcissus" as ultimately the primal condition of the Subject. See Nouvet, "An Impossible Response: The Disaster of Narcissus," *Yale French Studies* 79 (1991): 103–34.

of the words to the contour of the passage (the patterns of high and low pitches) and its rhythms (the patterns of short and long durations), and even invites you to hum or tap along with it. In fact, part of what it means to listen to something musically is to *participate* imaginatively.[108]

With this in mind, we consider repetition to be central to an analysis of the musicality of a philosophical conversation and the imaginative bodily participation of other theorists of the Young-Girl.

We have frontloaded this book with a relatively lengthy introductory chapter to perform a more efficient focus on two orienting concepts for navigating the acoustic space of theories of the Young-Girl—iteration and orality. Centering on each of these two concepts, the following body chapters listen to critico-contextual objects and textual critiques that engage with the rhythms of the Young-Girl across platforms and networks. In chapter 1, "Iteration," we argue that the figure of the Young-Girl is a machine for generating variants across visual art, theater, creative writing, and cultural criticism. We also offer a definition of theory's political style equally inspired by literary studies and scholarship on political rhetoric. In chapter 2, "Orality," we focus on relations between orality, literacy, and political power through individual and collective performances of voicing the Young-Girl. The orchestration of speech by gossip, chants, *dictées,* social media, and the activist practice of the human mic—and the speechlike digitexuality of LISTSERV convos and DMs—provides the conditions for the emergence of the Young-Girl as a highly contested political subject at the boundary between visual and oral language. Chapter 3, "Conclusion, or Fucking Up," returns to call-and-response as a formal principle of theories of the Young-Girl writ large through a discussion of Nesrine Khodr's video *Tahrïk* and its oral performance of iteration.

108. Elizabeth Hellmuth Margulis, "Why Repetition Can Turn Almost Anything into Music," *Aeon,* March 7, 2014, https://aeon.co/essays/why-repetition-can-turn-almost-anything-into-music.

1. Iteration

Did you ever see Sally make water?
She pisses a beautifull [*sic*] stream
she can piss a mile and a quater [*sic*]
she's a regular pissing machine

Did you ever see Sally make water?
She pisses a beautifull [*sic*] stream
she can piss a mile and a quater [*sic*]
you can't see her ass for the steam.

Have you seen our Sally make the water
She sits and makes a flowing stream
She piddles 3 pints and a quarter
And you can't see her bottom for the steam

—*three variations of a children's vernacular song, the first from New
York in the 1940s, the second from Florida in the 1960s, and the
third provided by an internet commentator, without a specified
date or time period*

Grinding Iteration

One of Tiqqun's conversation partners is Mohammad Salemy, an
Iranian-born artist, critic, and curator. His contribution to the dis-
cussion is the now defunct *Preliminary Materials for Any Theory*
(2014). A work of internet art that transformed the title of Tiqqun's
text into a game in the style of Mad Libs, *Preliminary Materials
for Any Theory* allowed users to input new words into the title's

basic grammatical structure and to choose preferred gendered pronouns to be inserted into the body of the text. *Preliminary Materials for a Theory of the Confused-Starling. Preliminary Materials for a Theory of the Tiny-Switchboard. Preliminary Materials for a Theory of the Carnivorous-Hashtag. Preliminary Materials for a Theory of the Theoretical-Theories* (in an analogy worthy of German surrealist Hans Bellmer, Martin Elwell, writing for *The Found Poetry Review,* mentions offhand that he replaced "Young-Girl" with "Dirty-Sphere." Barf.).[1] New titles appeared on facsimiled covers, in thumbnail form, lipstick red as the original. The site then provided the first few pages of Reines's English translation, taken from an online publication of a section of the book by arts organization Triple Canopy, as a PDF with all relevant words altered.

Salemy took the rhetoric of Tiqqun's theory to a playfully absurd extreme. If the Young-Girl, as Tiqqun claim, can really be a child or adult, queer or straight, a man or a woman (or, we are to assume, neither or both)—that is, anybody and everybody subject to late capitalism's processes of Young-Girlization—if she need not be young and need not be girl, then perhaps she need not necessarily be a Young-Girl either. Indeed, she is not only every body but also every thing, in the way that money is one thing that can be transformed into most any thing ("The 'anthropomorphosis' of Capital," "living money," the Young-Girl is full of infinite potential).[2] *Preliminary Materials for Any Theory* performed the limit case of the Young-Girl's condition by giving us a Young-Girl so Young-Girly that she is no longer a Young-Girl at all. In a similar fashion, New Zealand–born, London-based artist Stacey Teague writes, "The Young-Girl is everything, anything. The Young-Girl erases the meaning of The Young-Girl."[3]

1. Martin Ewell, "Finders Keepers: This Is Just to Say . . . Pound Never Went Viral!," *Found Poetry Review,* July 26, 2015, http://www.foundpoetryreview.com/blog/finders-keepers-this-is-just-to-say/.

2. Tiqqun, *Preliminary Materials,* 17, 92.

3. Stacey Teague, "Female Young Messiah," in *The Young-Girls Gaze*

Salemy's site arranged thumbnails of covers created by previous users in a grid pattern. In this way, *Preliminary Materials for Any Theory* resembled an image macro meme generator, with the solid pinkish-red rectangular cover as the image on which users' text was superimposed. The cover of Reines's translation was thus not duplicated but iterated, with the regularity of the visual rhythm of evenly spaced rectangles serving to highlight, by contrast, the differences between each title. Salemy's work made the provocative claim that *Preliminary Materials* is a text defined not by its content or even its context but by its sheer iterability, a quality that is fundamental to networked culture. "It's the way of the Web these days," writes Ben Zimmer for the *New York Times Magazine*; "everything is *iterating*."[4]

Zimmer's brief but insightful investigation of the currency of the word *iterate* is worth considering at length. Although it originally meant "done again," and "had been associated with little more than dull monotony," *iterate* was taken up by mathematics and later, computer science to refer to the process of repeating a formula or program to produce a series of different results.[5] Software designers began using the term to indicate the incremental *improvement* of a particular application. "Now being skilled at *iterating* has emerged as a prized trait among the digital set," Zimmer explains. "A recent job listing for a software-development engineer at Amazon singled out the 'ability to iterate on an idea' as a critical qualification."[6] Iteration is central to both digital industries and vernacular digital culture, the latter based largely on an iterative "'copy the instructions,' rather than 'copy the product' model of replication

at Soma Contemporary (Waterford, Ireland: Soma Contemporary Gallery, 2014), 46, https://issuu.com/aoifeodwyer/docs/bunny_cataloguel.

4. Ben Zimmer, "Iterate," *New York Times Magazine,* June 13, 2010, https://www.nytimes.com/2010/06/13/magazine/13FOB-onlanguage-t.html.

5. Zimmer.

6. Zimmer.

and variation," as Jean Burgess describes the manner in which user-generated responses to viral videos disseminate on YouTube.[7]

However, while iteration in business and design is allegedly a process of progressive enhancement, it sometimes ends up being less about making something function *better* and more about making something function *differently* (which, in the case of software, makes corporations more money by encouraging people to buy these new versions of the software and new hardware to support these new applications). In the case of iterative memetic images, which include the user-generated videos Burgess theorizes, subsequent variants are not necessarily better, that is, more interesting, clever, or visually arresting, than prior ones. Memetic iteration, not mentioned in Zimmer's analysis, is a kind of iteration that is not about progress but about continuing the basic rhythmic pulse, with the introduction of some harmonic paradigm or a new rhythmic embellishment.

In this chapter, we identify such nonprogressive, nonteleological iteration as a fundamental operation in theories of the Young-Girl across visual art, theater, and text-based criticism. *Preliminary Materials for a Theory of the Young-Girl* is itself iterative, featuring the rhythmic reappearance of the name of their antagonist attached to a series of differing phrases. For example, in the body of the text, we learn that "The Young-Girl is . . ." over and over again. "Hundreds of sentences," reviewer Nina Power estimates, grumbling about the text's "grinding repetition" (hearing in the voice of Narcissus another Echo, but at her least creative).[8] And what is the Young-Girl? She is "a *vision machine,*" "a *polar figure,*" "the elementary social relation," "an instrument of degradation," "a design element," "true gold," "a reality as massive and crumbly as the Spectacle,"

 7. Jean Burgess, "'All Your Chocolate Rain Are Belong to Us?': Viral Video, YouTube and the Dynamics of Participatory Culture," in *Video Vortex Reader: Responses to YouTube,* ed. Geert Lovink and Sabine Niederer (Amsterdam: Institute of Network Cultures, 2008), 108.
 8. Power, "She's Just Not That into You."

"an oxymoron," the list goes on.[9] Boom boom boom. The text is an accumulation of variants, like *Preliminary Materials for Any Theory,* a database for iterations. Megan Arlett thinks Tiqqun's argument is both reiterative and incantatory: "These aphorisms build and build throughout the texts, repeating the term 'Young-Girl' into a kind of chant: the Young-Girl X, the Young-Girl Y, the Young-Girl Z."[10] A chant. An algorithm. An algorithmic chant. Arlett's essay is called "A Preliminary Theory on Kissing." A musical interpretation of *Preliminary Materials* on SoundCloud keeps returning to a sample from Suzanne Vega's "Tom's Diner" (1987), asking us to hear Vega's "Do do do do do dodo do" in new ways as the underlying trance rhythm wanders and the sonic atmosphere becomes denser.[11]

Over the course of its 144 pages, *Preliminary Materials* replaces the logic of a typical philosophical argument with grinding *iteration.* Let's linger on this maneuver for a moment. Central to the text's characteristic style, grinding iteration conjoins *Preliminary Materials*'s affective impact (it irritates the reader) with its form (difference within repetition). Whether perceived as a motivation, inflammation, or relentless bore, grinding iteration as a rhetorical strategy invites a productive consideration of textual style outside of its customary frame within literary studies, which understands style as an author's identifiable voice, tone, and formal inclinations. More specifically, we might fold together this conventional idea of literary style with the concept of political style as *"a coherent repertoire of rhetorical conventions depending on aesthetic reactions for political effect."*[12] For Robert Hariman, whose definition we borrow here, political style "account[s] for the role of sensibility, taste, man-

9. Tiqqun, *Preliminary Materials,* 14, 15, 62, 70, 71, 96, 131, 131.

10. Megan Arlett, "A Preliminary Theory on Kissing," *Pinch,* November 15, 2019, http://www.pinchjournal.com/cnfpinch/2019/11/15/a-preliminary-theory-on-kissing-by-megan-arlett.

11. "Tiqqun" (affect trance), "Preliminary Materials towards a Theory of the Young-Girl."

12. Robert Hariman, *Political Style: The Artistry of Power* (Chicago: University of Chicago Press, 1995), 4.

ners, charisma, charm, or similarly compositional or performative qualities in a particular political culture."[13] Hariman develops his theory of political style through close readings of certain texts that provide theories of political actors and conditions of power. After close listening to Hariman's *Political Style: The Artistry of Power*, *Preliminary Materials*, and theories of the Young-Girl writ large, we propose an amended definition of style that weaves together threads from literary studies and research on political rhetoric: a theory's *textuo-political style* is the characteristic formal and affective manner through which it animates political subjects and the formal and affective mannerisms of the responsive political subjects it participates in bringing into being. Unlike literary style, which isolates and individualizes the author—indeed, the emergence of literary style, "conceived as a way of writing unique to a particular individual, one who does not aspire to submit to collective conventions of composition, was thus coextensive with the rise of the bourgeois individual as such"—*textuo-political style* includes readers' reactions to the text and to each other as constitutive but not predetermined artistry.[14] The cacophon that is textuo-political style accounts for compositional and performative actions coproduced by the readers themselves and the affordances of the text, regardless of authorial intention.

Key to *Preliminary Materials*'s textuo-political style, the strategy of grinding iteration is emphasized by a boldfaced list of sentences that appears in chapter 7, "The Young-Girl as War Machine." All ten sentences in the list begin with "The Young-Girl has declared war on . . ." And on what, you ask? On "GERMS," "CHANCE," "PASSION," "TIME," "FAT," "OBSCURITY," "WORRY," "SILENCE," "POLITICS," and even "WAR" itself, despite her status as a "War Machine."[15] This iterative chain uses the format of the list to provide the visual

13. Hariman, 3–4.
14. Daniel Hartley, *The Politics of Style: Towards a Marxist Poetics* (Leiden, Netherlands: Koninklijke Brill, 2017), 16.
15. Tiqqun, *Preliminary Materials*, 113, 105.

appearance of linearity without what McLuhan calls "lineal" logic.[16] Chapter 7 thus gives us the poetics of the most basic thread on social media, an accumulation of individual utterances that "build and build" in response to an original post.[17] Here Tiqqun's rhetoric is a boring or annoying machine shitting out a turdlike iterative series, and Tiqqun/the enlightened reader of theory is a political subject as active media *user* of that machine.

This ten-sentence series is an echo of another ten-sentence series, the list of ten chapter titles in *Preliminary Materials*'s table of contents. The first seven chapters all begin with "The Young-Girl as . . ." ("The Young-Girl as Phenomenon," "The Young-Girl as Technique of the Self," "Social Relation," "Commodity," "Living Currency," "Compact Political Apparatus," and "War Machine") and the next two with "The Young-Girl Against . . ." ("Communism," "Herself"). This fairly regular rhythmic run of "The Young-Girl . . ." is rudely interrupted by the title of the final chapter, "Putting an End to the Young-Girl." Reading the first nine titles in the table of contents, we are reminded of double-dutch jump rope chanting games in which new words are inserted into the flow of a pulse that must be maintained if the jumper is to continue. By establishing and then, in the end, disrupting the rhythm of the text's list of chapter titles, the table of contents anticipates the tactic that the body of the text proposes: to rid ourselves of the Young-Girl and be properly empowered political actors, we must throw ourselves into her rhythm and then trip, fuck it up, fuck her up, stop the rope's mesmerizing rotation, end the chant, stop the game.

While the table of contents suggests that putting an end to rhythmic regularity and its ease of entrainment is "Putting an End to the Young-Girl," and the body of the text claims to provide the tools for ending the Young-Girl's life, the rhetoric of the text unwittingly

16. Marshall McLuhan, "The Agenbite of Outwit," *McLuhan Studies* 1, no. 2 (1996), http://projects.chass.utoronto.ca/mcluhan-studies/v1_iss2/1_2art6.htm.

17. Arlett, "A Preliminary Theory on Kissing."

implies that she might never end. "The Young-Girl is . . . ," "The Young-Girl is . . . ," the Young-Girl is . . . everything, it seems. If she is indeed everything and anything, then she is an infinite series, a being without end. There is no "Young-Girl Z." Or perhaps we are to hear the text as saying that it is not the Young-Girl herself but Tiqqun's brutal critiques that have the ability to continue past the book's final page. When taken to the max, critique as a potentially unending series of denunciations functions like an image macro meme generator. That is, critique becomes Salemy's *Preliminary Materials for Any Theory*.

Other artists have participated in theorizing the Young-Girl by reproducing the seriality and rhythmic urgency present in much of Tiqqun's text. For example, Irish artist Samantha Conlon's *i pledge allegiance to the young-girl* (2015), one of a large number of works she created in response to *Preliminary Materials,* is a silkscreen of a column of text printed in lavender on a piece of silk suggesting a flag. Every line begins with "I pledge allegiance to . . ." To what? "Sexts," "lying," "her," "illusion," "rot," "nudes," "misery," "womb," "worship," "fame," "heaven," "waste," "dread," and, finally, "girlhood."[18] While Conlon hasn't chosen these words randomly ("worship" and "fame" resonate with her oeuvre's emphasis on female celebrity; "rot" and "illusion" are words used in *Preliminary Materials*), it is visual rhythm and the oral-aural pulse internalized by the reading viewer—and not meaning—that dominates *i pledge allegiance to the young-girl*.[19]

Conlon's response to *Preliminary Materials* does little quoting from the text itself—there is no "pledg(ing) allegiance" in the book, a point to which we will soon return—and is not a clear critique of

18. Samantha Conlon, "i pledge allegiance to the young-girl," *Samantha Conlon,* http://www.samanthaconlon.com/i-pledge-allegiance-to-the-young-girl/.

19. Key quotations from *Preliminary Materials* include "When she loses the possibility of re-entering the marketplace, she begins to rot" and "The Young-Girl is an optical illusion." Tiqqun, *Preliminary Materials,* 88, 45.

Tiqqun's argument. Her rejoinder is instead a *continuation* of the book's iterative, rhythmic motifs. But unlike Tiqqun's list of chapter titles, the rhythm of Conlon's work remains regular to the end. There is no "Putting an End to the Young-Girl" as an attempt to arrest the rhythms to which Conlon—or her stand-in, the reader-viewer as "i"—pledges allegiance. The text may stop, but we both keep on standing there awkwardly with our hands over our hearts, facing a flag.

When Conlon does Tiqqun (that is, when she reperforms Tiqqun's iterative and rhythmic strategies), there is another difference. Conlon does not disclaim her Young-Girliness. With *Preliminary Materials,* on the other hand, the authors position themselves and, we maintain, their readers as *not* Young-Girls, despite the capacious formulation of the book's antagonist as a generic conceptual persona applicable to subjects across lines of identification. Tiqqun stand opposite the Young-Girl, who is their object of derision and repulsion. As Sarah Gram reminds us vis-à-vis *Preliminary Materials,* "disgust is about contempt. It polices the boundaries between observer and observed."[20] Tiqqun's Young-Girl is a "she" over there, not a "we" over here. Or rather, "the Jeune-Fille is *them*" (and not us), a statement from the poem, previously mentioned, included in Lopez and René-Worms's performance *Bubble Boom, the Jeune-Fille said: a bit of bubble and a little bit of boom* (2015). As the poem proceeds, it becomes a troubling fantasy about the "penetrat[ion]" and death of the Young-Girl.[21] Lopez and René-Worms imagine violating the "them" of the Young-Girl through "ammoniacal" perfume; Tiqqun mercilessly mock her by mimicking the mode of address of supermarket fashion magazines and beauty advertisements, such as "Because I'm worth it!," a quotation of L'Oreal's tagline.[22] Importantly, the "I" that claims to be worth it in *Preliminary Materials* is not the "I" of the writers or even the reader, who is not asked to identify with the

20. Gram, "The Young-Girl and the Selfie."
21. Lopez and René-Worms, "Bubble Boom."
22. Lopez and René-Worms; Tiqqun, *Preliminary Materials,* 84.

Young-Girl as subject of advertising (and the "them" whose body is "penetrated" by "colours" in Lopez and René-Worms's poem is not to be mistaken for an "us"). The us-versus-them quality of Tiqqun's argument, a division maintained throughout *Preliminary Materials* via its politics of disgust, reflects an unfortunate "tendency evident throughout Tiqqun"—a residual "politics of identity" that contradicts the collective's argument against individualized, packaged subjectivity. As Nicholas Thoburn explains,

> the declared process of becoming anonymous takes the form and injunction of identification with a "we" or an "us" against a "they." Ejecting capitalist relations by force of will and acts of marginal lifestyle—externalizing the "they," in other words—this "us" becomes a privileged subject or party, despite protestations to the contrary and however various and fragmented its composition.[23]

Conlon's allegiance pledger, on the other hand, is not a "they" but an "i," a lowercase "i," not "worth it" enough for L'Oreal, we assume. This "i" may be Conlon the creator, owning up to being a participant in capitalism's imperious victory cheers, and/or the viewer-reader, whose internal voice is asked to embrace the rhythms of Conlon's text without what some perceive as *Preliminary Materials*'s ironic distance.

Of course, when interpreted most literally, to pledge allegiance to the Young-Girl is not exactly to *be* the Young-Girl any more than to pledge allegiance to the flag of the United States of America makes one a rectangular piece of polyester or to pledge allegiance to Satan makes one indistinguishable from the Dark Lord. That said, pledging allegiance is a performative that brings into being one's flaglike qualities, Americanness, or Satanic affinities, if only in their most rudimentary form. When we pledge allegiance in the manner of U.S. schoolchildren, who do so together and out loud (if not in the manner of Satanists, of which we are not acquainted), we bring ourselves into an often uncomfortable bodily alignment with things,

23. Thoburn, *Anti-Book*, 222.

ideas, and other people through rhythmic entrainment, regardless of the authenticity of the performance. While Conlon's *i pledge allegiance to the young-girl* invokes a coercive rhythmic oral-aural ritual associated with youth as a response to the oral-aural rhythms of *Preliminary Materials,* the specificity of pledging allegiance brings into being a Young-Girly "i" and "we" absent from the text itself.

Conlon is a founding member of a Young-Girly "we" called Bunny Collective, a group of artists based in Ireland and the United Kingdom. The catalog essay for their 2014 exhibition at Soma Contemporary Gallery in Waterford, Ireland, titled *The Young-Girl's Gaze,* emphasizes the relationship of identification between the participating artists and Tiqqun's bogey(wo)man. In other words, the Young-Girls who gaze are the artists themselves. More specifically, author Kathryn O'Reagan, responsible for the catalog essay, describes a triangular relation between Bunny Collective, Tiqqun's Young-Girl, and all the young women of the world who "have harnessed the Internet as a space of self-expression and subversive potential."[24] This nostalgically named "cyber-sisterhood" of "Young-Girls" uses social media "to investigate the multivalency and dynamism of female identity," attempting to become feminist revolutionaries of sorts through digital media.[25] Bunny Collective, O'Reagan writes, is a family of cybersisters who make art about this resistant digital girl culture as well as a girlsquad that owes its existence to social media as tools for group promotion, communication, and transnational coherence. Our point here is not to affirm the efficacy of social media platforms in promoting radical feminism or to argue for the radicality of Bunny Collective; instead, we want to note this new iteration of the Young-Girl as intended feminist freedom fighter, a role irreconcilable with the one written by Tiqqun, and yet not, in O'Reagan's essay, explicitly framed as a critique or revision

24. Kathryn O'Reagan, "Cyber-sisterhood: Introducing Bunny Collective," in *The Young-Girls Gaze at Soma Contemporary,* 5, https://issuu. com/aoifeodwyer/docs/bunny_catalogue1.

25. O'Reagan, 4, 7.

of *Preliminary Materials.* "The Young-Girl is everything, anything. The Young-Girl erases the meaning of The Young-Girl," to repeat the words of participating artist Stacey Teague.[26] The Young-Girl's ability to iterate trumps her content.

The catalog reproductions of the art from the show include Conlon's *The Young-Girl Declares War*—a wall-sized photographic print, split into strips in the style of a billboard, of a young woman's neck and the lower portion of her face, with the word "surrender" cutting across her throat—and Teague's *Female Young Messiah,* a series of photographic portraits of three of the artist's friends paired with quotations from *Preliminary Materials.*[27] Teague's artist statement includes the admission "The Young-Girl is my friend." Here we have a different affirmation of affinity with the Young-Girl than Conlon's pledge of allegiance to the girl-flag and O'Reagan's equilateral triangle, and certainly much different than the war Tiqqun wage against the face and body of Empire. Looking at Teague's contribution to *The Young-Girl's Gaze,* we ask ourselves, How might the theory of the Young-Girl be different if the Young-Girl were a friend and not an enemy? Actually, what if she were not just a friend but a series of friends like Teague's, all framed from the knees up, all standing straight with arms down, staring down the camera with a level gaze, all variations on a theme, iterative?

"It's the way of the web these days: everything is *iterating.*"

Because I'm/You're/We're Worth It

Conlon's body of work responding to *Preliminary Materials,* most of which was not part of *The Young-Girl's Gaze,* is extensive. One of the most memorable is the video *The Young-Girl Blames Herself* (2014), which includes a morphed sequence of appropriated photographs

26. Teague, "Female Young Messiah," 46.
27. Samantha Conlon, "The Young-Girl Declares War," in *The Young-Girl's Gaze at Soma Contemporary,* 17, https://issuu.com/aoifeodwyer/docs/bunny_catalogue1; Teague, "Female Young Messiah," 47.

capturing the troubled celebrity Lindsey Lohan from childhood to adulthood.[28] Lohan's face grows, shrinks, and shifts grotesquely with a regular pulse as each new image is introduced (the pictures are not matched exactly in size and pose, resulting in the expansion and contraction of her features). Importantly, despite the sequence's chronological nature, it does not trace the teleological development of a little girl into a mature woman. The majority of the images are from Lohan's adulthood and do not constitute a run in which the actress gets visibly older (or prettier or uglier or happier or sadder) by degrees. This is not a narrative of progressive evolution or even incremental decomposition, of upward mobility or tragic downfall. Instead, this is a series of different Lohans that looks like it could continue without end, an iteration produced by a rhythm that appears to have an agency of its own. (BUBBLE) BOOM new Lohan (BUBBLE) BOOM new Lohan (BUBBLE) BOOM new Lohan: mugshot Lohan, lip gloss Lohan, cheery Lohan, fat-lipped Lohan, passed-out Lohan, cut-cheekbones Lohan, no-freckles Lohan . . . a potentially infinite number of Lohans. After all, the public figure known in the blogosphere as La Lohan—and, capitalist uses of Young-Girliness more generally—is most valuable to her consumers as a kind of computational generator of Lohan variations (and La Lohan can no longer be La Lohan once she fails to generate new versions). When Lindsay Lohan was at the height of her popularity, she most fully occupied the machine called La Lohan. She is certainly no longer there.

Tiqqun's idea of the Young-Girl is the La Lohan of political theory. It is as if the Young-Girl herself were a computational subroutine that produces an iterative series of descriptions and attributes, forming the distinctive rhythm of *Preliminary Materials* and its rejoinders. The programmatic and generative ability of Tiqqun's theory finds a related form on stage in *Manifesto of the Young-*

28. Shia Conlon, "The Young-Girl Blames Herself," Vimeo video, 4:51, 2014, https://vimeo.com/93072906.

Girl (Manifeste de la Jeune-Fille), written and directed by Olivier Choinière and performed by his company, l'Activité, in 2017 at the Espace Go theater in Montréal.[29] An adaptation of Tiqqun's manifesto in Choinière's original language, the play is staged as a parody of a fashion show, with seven actors (male and female Young-Girls of different ages) entering through a rotating closet and moving toward two illuminated circular podiums that function as soapboxes to showcase their outfits and isolate actors in small groups or individually for monologues. The closet—suggestive of rotating platforms in car showrooms, but positioned far enough upstage left so actors can enter from backstage unseen—behaves scenographically as a kind of machine for generating variations of the Young-Girl with different sizes, shapes, and obsessively changing lewks. Although the performance has a finite number of actors, of course, their small number is multiplied by the effect of extreme costume changes, including masks and wigs, giving us the feeling of a never-ending supply of raw material to fashion and spin out onto the stage. Making a mockery of revolutionary politics bubble boomed by capitalism, the revolving wardrobe is La Lohan rendered tangibly scenographic.

This machine, like all machines, processes animate and inanimate matter (something the Luddites of British history, to whom we will return in chapter 2, knew so well). In a visual argument suggestive of modernism's obsession with dolls and other stand-ins for the commodified female body, the set of *Manifesto of the Young-Girl* has white mannequin legs and busts sticking out of clothing displays, giving the impression that in/animate Young-Girls are either encased in or caught in the process of diving into the shop furniture. (Or maybe the geometrically aligned limbs of the Tiller Girls were broken off and discarded after their choreographic rhythms were extracted. Poor things.)

29. Olivier Choinière, *Manifeste de la Jeune-Fille* (Montreal: Atelier 10, 2017); "Manifeste de la Jeune-Fille," *Espace Go,* https://espacego.com/archives/2016-2017/manifeste-de-la-jeune-fille/.

The play opens to the dunz-dunz of EDM, its energy building, breaking, and then dropping. Each Young-Girl enters the La Lohan machine to model an outfit, walking to the beat and stepping up onto the larger podium to address the other actors and the audience at the same time. One asks, casually, "How is it going?" ("Ça va?"), followed by a positive but vacant response of "Super good!" ("Super bien!"). Repetition and variation are the centerpieces of the play's style. The actors often repeat each other's lines, seemingly ad infinitum.

Choinière picks up where trash theory about trashy girls leaves off. If we dismantle the La Lohan machine and the morphing mannequins it produces, what do we do with its parts? The play presents *recycling* as the answer, reframing the repetition and variation central to *Preliminary Materials* as an eco-politico-economic strategy of creative reuse. *Manifesto of the Young-Girl* recites, revoices, reverberates, remediates, and reiterates words in a series of language games that ask audiences to consider upcycling the massive, grinding dysfunctional machine of capitalism for its valuable parts. Moreover, the show brings environmental issues into its content with the character Joanie, a Young-Girl who aims to do good in the world by making extra sandwiches for the homeless she encounters on her way to work but is chided by the others for contributing to the mountain of plastic, since she wraps each sandwich in cellophane. While the ecological aspects of disassembly, reassembly, and reinvention are not a significant concern for *Preliminary Materials,* the connection between the appropriation of cultural products like images (as well as quotations from magazines, we might add) and the recycling of objects has already been made by French curator Nicolas Bourriaud in his theorization of postproduction art of the 1990s.[30]

Manifesto of the Young-Girl does not position itself as a critique of *Preliminary Materials.* Instead, it borrows and stages some of

30. Nicolas Bourriaud, *Postproduction* (New York: Lukas and Sternberg, 2002), 28–33.

the text's central ideas, adapting Tiqqun's iterational approach and translating *Preliminary Materials*'s language of magazines to the choreography of a fashion show and costumes that embody a wacky high-fashion sensibility (to be more precise, the costumes are a loose parody of high fashion's appropriation of streetwear). That said, it is ultimately a more hopeful presentation of the Young-Girl than is its predecessor. The show's title highlights a play on words between the French *manifestation* (which means "something that appears," as in its English counterpart, as well as "political demonstration") and *manifesto* (or "public proclamation"). As the performance progresses, each Young-Girl comes to a realization denied her by *Preliminary Materials*: "Today I will march/demonstrate!" ("Aujourd'hui je vais manifester!"). *Manifesto of the Young-Girl* allows for the possibility that the manifesto *of* the Young-Girl may not only be *about* her but also be *possessed by* her, and that the rhythms of the catwalk can be morphed into the rhythms of the political march.

About fifty minutes into the performance, the characters join a political protest they can hear but not see. Prior to their exit, a Young-Girl named Maude shouts "listen" ("écoutez") seventeen times in a row, directing the others' attention away from their discussion about the role of religion in society and toward a ruckus outside. The Young-Girls soon understand that the explosions originate from a group that has spontaneously formed and is marching in the street "shouting slogans." Though the Young-Girls don't know the reason for the demonstration, they leave the stage to participate. In their absence, footage from Montréal's 2012 student protests is projected on two upstage screens. The series of strikes and demonstrations known as the Maple Spring began in opposition to a proposal to raise university tuition; support broadened when a bill was passed to ban demonstrations on or near university grounds (Bill 78). Echoing the French student strikes of May 1968 and Québec's Quiet Revolution of the same year, Québécois students performed a later iteration of youthful defiance. Boom. Choinière's Young-Girls leave one by one to protest an unknown oppression. Boom. They march. Boom. Tear gas clouds the screen. Boom. Flash-bang gre-

nades are thrown. Boom. We see the mask of hacktivist collective Anonymous moving in the crowd of student protesters.

Surprisingly, perhaps, when the Young-Girls return from the protest, they continue their catwalk circuit, albeit with less enthusiasm. In other words, they haven't permanently swapped modeling for protesting. Though the production is, in part, critiquing the Young-Girls' temporarily passionate alignment with the protests as another fashionable cause as easily put on as a new outfit, the issues that are brought up in their discussions (tear gas, police brutality, human rights violations) demonstrate that it is as much a calling out of those in the audience who do even less to combat injustice and inhumanity. *Manifesto of the Young-Girl* does not reconcile the seemingly oppositional pursuits of vanity and political involvement. Instead, we might more accurately consider the play's transformation of Tiqqun's vacant and useless feminine nothing into an "I" that "will march" in alliance with others as a kind of polyrhythmic composition overlaying the rhythms of mass consumption with the rhythms of mass demonstration.

Manifesto of the Young-Girl may have a compound cross-rhythmic take on *Preliminary Materials,* but it is not entirely contrary. Other interlocutors adopt an explicitly oppositional stance toward Tiqqun's text, often also by making use of the particular affordances of iteration. These critiques reorient the theory of the Young-Girl's algorithmic, generational capacity for their own subversive ends, frequently iterating the name of the figure as well as descriptions and attributes. Indeed, theories of the Young-Girl writ large are full of antagonists and protagonists with two-part names fashioned to outmuscle Tiqqun's Young-Girl. Proposed replacements for "Young-Girl" in the popular critical literature include "Man-Child," "Sad Girl," "Hot Babe," "Adult-Man," and "hipster" (the latter from an article supporting Tiqqun's theory, but offering a "marginally less inflammatory" name).[31] Coming up

31. Weigel and Ahern, "Further Materials toward a Theory of the Man-Child"; artist Audrey Wollen explains the connection between her Sad

with new characters has become a kind of fun feminist game in the more playful corners of Young-Girl discourse.

"Man-Child" is by far the most discussed substitute. It comes from Weigel and Ahern's "Further Materials toward a Theory of the Man-Child," published online in the *New Inquiry* in 2013 (notably, given the acoustic framework of this study, Charlotte Frost describes the *New Inquiry* as "something akin to a 'movement' rather than simply a publication. It was about finding and uniting these disgruntled voices [of the precariously employed] in a louder critical cacophon").[32] Published in the same issue as Hannah Black's "Further Materials for a Theory of the Hot Babe," Weigel and Ahern's piece is a humorous condemnation of the rhetoric of *Preliminary Materials*. The authors argue that despite Tiqqun's insistence that they have "lady members" (pun intended), *Preliminary Materials* only confirms that "the protagonist of contemporary radical politics styles himself as a *him*." Weigel and Ahern aren't buying the book's "ironic performance of misogyny" or its anonymous (really, pseudonymous) authorship as an expression of "solidarity." The book is sexist, straight up, part of "a long intellectual tradition that uses 'woman' as shorthand."[33] Tiqqun are not woke baes but fuckboys in disguise, as journalist Marquaysa Battle would say.[34]

Girl Theory and *Preliminary Materials* in a no longer extant interview formerly available at http://www.cultistzine.com/2014/06/19/cult-talk-audrey-wollen-on-sad-girl-theory/; Hannah Black, "Further Materials toward a Theory of the Hot Babe," *New Inquiry,* July 15, 2013, https://thenewinquiry.com/further-materials-toward-a-theory-of-the-hot-babe/; Alicia Eler, "Now Accepting Materials toward a Theory of the Adult-Man," *Hyperallergic,* July 16, 2013, https://hyperallergic.com/75487/now-accepting-materials-toward-a-theory-of-the-adult-man/; Rob Horning, "Hi Haters!," *New Inquiry,* November 27, 2012, http://www.thenewinquiry.com/hi-haters.

 32. Frost, *Art Criticism Online: A History,* 188.
 33. Weigel and Ahern, "Further Materials toward a Theory of the Man-Child."
 34. Marquaysa Battle, "Signs Your 'Woke Bae' Is Actually a Fuckboy in Disguise," *Elite Daily,* March 14, 2017, https://www.elitedaily.com/women/woke-bae-fuck-boy-dating-signs/1824890.

Weigel and Ahern choose to replace the Young-Girl with the "Man-Child," their name for Tiqqun and leftist misogynists more generally. For Weigel and Ahern, the Man-Child is the Young-Girl iterated into a new object of critique. "Talk[ing] Tiqqun talk" (a strategy common throughout the field of responses to *Preliminary Materials*), the authors write an extended diatribe against their antagonist, including the following statements:

> The Man-Child wants you to know that you should not take him too seriously, except when you should. At any given moment, he wants to [sic] you to take him only as seriously as he wants to be taken. When he offends you, he was kidding. When he means it, he means it. What he says goes.
> The Man-Child thinks the meaning of his statement inheres in his intentions, not in the effects of his language. He knows that speech-act theory is passé. . . .
> Why are you crying? The Man-Child is just trying to be reasonable. This is his calm voice. . . .
> Just as not all men are Man-Children, neither are all Man-Children men.[35]

The Man-Child, they write, historically developed as a response to the feminization of labor, an issue that also motivates Tiqqun to write *Preliminary Materials*. But while Man-Children can make some good points about the gendered aspects of the capitalist exploitation of workers, they misdirect their criticism, cloak sexist rhetoric in irony, and offer no compelling solutions. Weigel and Ahern close with the provocation "what would *Preliminary Materials for a Theory of Motherhood* look like?"[36]

The Man-Child has proven to be a compelling idea for scholars and cultural critics. An edited academic volume on musical prodigies has a mystifying application of the term, considering the specificity of the Man-Child to theory-loving, irony-sporting leftists: Weigel and Ahern's concept is suggested as a possible frame

35. Weigel and Ahern, "Further Materials toward a Theory of the Man-Child."
36. Weigel and Ahern.

for the persona of popstar Justin Bieber (but ultimately rejected as insufficient for failing to account for the feminized "domesticity" of Bieber's videos).[37] Less surprisingly, it is used to illuminate a racist and misogynist music video for the Pixies' "Bagboy" (2013).[38] It also inspired an art exhibition, *The Politics of Friendship* (2013), for which the primary participating artists (Anicka Yi, Jordan Lord, Lise Soskolne, and Carissa Rodriguez) procured graphic and textual responses, including very short essays from Ahern and Weigel. A contribution by artist Lisa Jo appropriates the branding of Monster energy drink, an acid green M that looks like three parallel claw scratches from an irritable werewolf, and replaces the name of the product with "MANCHILD."[39] The cover of the exhibition catalog has an image of the words "man," "child," "young," and "girl" carved into a thin coating of yellow grease.[40] This is presumably a photograph of the gallery walls, which were covered in butter by Yi, Lord, Soskolne, and Rodriguez in reference to the lubrication used by the character Paul to rape Jeanne in Bernardo Bertolucci's *Last Tango in Paris* (1972).[41] Actress Maria Schneider has spoken out against Bertolucci for adding the scene without her permission in order to elicit an unsimulated reaction to abasement.[42] Making a brief

37. Tyler Bickford, "Justin Bieber, YouTube and New Media Celebrity: The Tween Prodigy at Home and Online," in *Musical Prodigies: Interpretations from Psychology, Education, Musicology and Ethnomusicology,* ed. Gary E. McPherson (Oxford: Oxford University Press, 2016), 763.

38. Jude Ellison Sadie Doyle, "The Pixies Enter the Realm of the Man-Child," *In These Times,* July 10, 2013, https://inthesetimes.com/article/the-pixies-bagboy-video-and-indie-rock-privilege.

39. Anicka Yi, Jordan Lord, Lise Soskolne, and Carissa Rodriguez, *The Politics of Friendship* (Zurich: Studiolo, 2013), http://s3.amazonaws.com/contemporaryartgroup/wp-content/uploads/2013/11/politics-of-friend-shipweb.pdf.

40. Yi et al.

41. Kari Rittenbach, "Anicka Yi: Narratives of Scent and Material Decay," *Frieze,* January 11, 2013, https://www.frieze.com/article/anicka-yi.

42. Anna North, "The Disturbing Story behind the Rape Scene in Bernardo Bertolucci's Last Tango in Paris, Explained," *Vox,* November 26,

reference to Schneider's violation, Soskolne articulates her own stance on both Tiqqun's concept and Weigel and Ahern's response:

> Efforts to finely distinguish between the Young-Girl and the Man-Child, and arguments about whether embodying the system within which we function is a superior critical strategy to pretending to function outside of it are to miss the point: we are each capable of cruelty under any circumstances. Until that very basic fact is acknowledged we will all continue to be butter under capitalism.[43]

The butter decomposed over time, undoubtedly perfusing the gallery with the retching smell of butyric acid, also a component of mammal sweat. "When she loses the possibility of re-entering the marketplace, she [the Young-Girl] begins to rot."[44] So does, Soskolne suggests, the Man-Child.

While there has been widespread interest in the idea of the Man-Child, Weigel and Ahern have also been brought to task. They have been critiqued for failing to provide "any kind of structural analysis of capitalism"; for neglecting to put *Preliminary Materials* into relation with other texts written by Tiqqun, namely, *Theory of Bloom* and *Sonogram of a Potential*; and for "assimilating the figural to the real, as if Young-Girl were an idea, a concept, of actually existing young girls."[45] After all, writes Critila for online anarchist publication the *Anvil Review,* confusing the Young-Girl with young girls is as dopey as assuming that Deleuze and Guattari really "think psychotics should be shuffled into the place of the revolutionary subject."[46] A MetaFilter thread offers some choice insults; one of

2018, https://www.vox.com/2018/11/26/18112531/bernardo-bertolucci-maria-schneider-last-tango-in-paris.

43. Soskolne, untitled, in Yi et al., *Politics of Friendship.*

44. Tiqqun, *Preliminary Materials,* 88.

45. Mike Bulajewski, "What Comes after the Man-Child?," *Meta Reader* (blog), July 22, 2013, http://www.metareader.org/post/what-comes-after-the-man-child.html; Critila, "Mind the Dash," *Anvil Review,* December 19, 2013, https://theanvilreview.org/print/mind-the-dash/.

46. Critila, "Mind the Dash." Tumblr user Tremblebot also defends *Preliminary Materials* by connecting it to the work of Deleuze and Guattari:

the more colorful among them describes Weigel and Ahern's article as "the usual nonsensical pre-copernican fare."[47] One commentator snarks, "Is this one of those machine-generated pieces of writing?"[48] Perhaps, another suggests, mansplaining the "Man-Child," Weigel and Ahern forgot that their "whole man-child construct was meta-ironic" and instead "went full circle past meta-irony and into sincerity."[49] Whoopsies.

A more pointed assessment comes from Dominic Jones, whose response is included in the exhibition catalog for *The Politics of Friendship*. Jones sharply critiques the authors' neglect of issues of race. "I will refer to Mal Ahern and Moira Weigel's 'Further Materials toward a Theory of the Man-Child' as the collective response of the White Woman."[50] The Man-Child, the Young-Girl, and the White Woman are all bound tightly together by white privilege, taking up all the oxygen in the room, leaving none for the [racialized] Other. "But the Other simply doesn't exist in our commodified society. He/she has nothing the Young-Girl, Man-Child or White Woman could possibly want or, more importantly, *need*. The Other is told to go occupy him/herself while the White people take time

"The theory of the Young-Girl articulated has nothing to do with actually being a young girl much like becoming-woman or becoming-wasp has nothing to do with being a wasp or a woman. The Young-Girl is an attractor, a molarity, and [*sic*] orientation and orienting figure." Tremblebot, "Preliminary Materials for a Theory of the Young-Girl," *Tremblings* (blog), May 26, 2012, http://tremblebot.tumblr.com/post/23806488132/preliminary-thoughts-on-materials-for-a-young-girl.

47. zoo, July 9, 2013, comment on GameDesignerBen, "Further Materials toward a Theory of the Man-Child," *Metafilter* (blog), July 9, 2013, https://www.metafilter.com/129823/Further-Materials-Toward-a-Theory-of-the-ManChild.

48. boo_radley, July 9, 2013, comment on GameDesignerBen, "Further Materials toward a Theory of the Man-Child."

49. ennui.bz, July 9, 2013, comment on GameDesignerBen, "Further Materials toward a Theory of the Man-Child."

50. Dominic Jones, "'Further Materials toward a Theory of the Man-Child': For White People, by White People," in Yi et al., *Politics of Friendship*.

sorting their issues out."[51] Ahern and Weigel's essay, as Jones states with cutting directness, is "For White People, by White People."[52]

"Further Materials toward a Theory of the Man-Child" is republished in 2014 as a hard-copy pamphlet paired with Jaleh Mansoor's "Notes on Militant Folds: Against Weigel and Ahern's Further Materials toward a Theory of the Man-Child," originally published online by the *Claudius App* the previous year. After the shuttering of the *Claudius App,* the essay is later slightly revised and released as simply "Notes on Militant Folds," a stand-alone pamphlet available on the website for the journal *Hostis.* Mansoor's essay is the most extended critique of Weigel and Ahern's concept and methodology. She argues that by replacing one figure with another, the Young-Girl with the Man-Child, Weigel and Ahern embrace a problematic "*brand* of feminism that takes symmetry for 'fairness,' 'equity' for 'equality,' as though those were not already part of the metrics on which our contemporary social relations are founded."[53] Mansoor turns to another of Tiqqun's texts, *Introduction to Civil War,* as support for her critique of the rhetoric of symmetrical exchange, which is central to neoliberal capitalism. Sure, she admits, *Preliminary Materials* "collapses the etiology of social pathology it diagnosis [*sic*] onto the object of its analysis . . . as though cis men and trans men were somehow 'free' of the problem."[54] "But the way out is not to construct an equivalent avatar to blame better," Mansoor insists, advocating instead for "exit[ing] this geometry of rationalization (capitalist accounting) entirely."[55] Additionally, Mansoor objects to Weigel and Ahern's turn to reproduction at the article's end ("What would *Preliminary Materials for a Theory of Motherhood* look like?"). She contends that reproduction, and the reduction of cis women to

51. Jones.

52. Jones.

53. Jaleh Mansoor, "Notes on Militant Folds," *Hostis,* 2018, 1–2, http://incivility.org/wp-content/uploads/2018/08/Mansoor-Militant-Folds.pdf.

54. Mansoor, 7.

55. Mansoor, 6.

their "dominant matrix," is still defined by capital (a criticism that could be leveled against motherhood-obsessed French antifeminists Les Antigones, discussed in the introduction).[56] Therefore the nonreproductive—"the luxury of pure expenditure without reserve"—might be a better site for conjuring new ways of being in the world.[57] George Bataille's ecstatic excess echoes grotesquely, beautifully, in our ears.

The cover of Mansoor, Weigel, and Ahern's pamphlet, titled *#Young-Girl,* is an advertisement for refrigerators that appears to be from the early 1960s. A pretty, bobbed brunette poses in four different outfits next to the appliance. In one, she's wearing a poncho and pedal pushers, in another, a turquoise day dress. This attractive floor model reminds us of another iteration of the Young-Girl, Hannah Black's "Hot Babe," whose "hotness" is "frozen, cold, zero degrees."[58] The Hot Babe "is the much-vaunted machine that comes to replace the mother." She is also the product of social media. "Her 'I' is generalized; although apparently totally individuated, without a shred of interest in collective life, the Hot Babe is always plural." Referencing the infamous Brazilian pornographic trailer featuring two actresses eating what appears to be shit out of a shared vessel, vomiting, and then eating the vomit—a viral video falsely identified in the *New York Times Magazine* as launching the phenomenon of the reaction video—Black describes the "Hot Babe" as "two girls, one cup; 2 million girls, one body."[59] L'Oreal's tagline iterated over the past forty years from "Because I'm worth it!" to "Because you're worth it!" to "Because we're worth it!"[60]

Inga Copeland (the alias of Russian Estonian musician Alina Astrova) returns to the original slogan for her album *Because I'm*

56. Mansoor, 11.

57. Mansoor, 11.

58. Black, "Further Materials toward a Theory of the Hot Babe."

59. Heather Warren-Crow, "Screaming Like a Girl: Viral Video and the Work of Reaction," *Feminist Media Studies* 16, no. 6 (2016): 1113–16; Black, "Further Materials toward a Theory of the Hot Babe."

60. "15: L'Oréal (1971)—because I'm Worth It," *Creative Review,* https://www.creativereview.co.uk/because-im-worth-it-loreal/.

Worth It (2014), a sonic exploration of *Preliminary Materials*.[61] The title track is a recording of Copeland whispering the *Preliminary Materials* quotation "Because I'm Worth It" looped over the course of the song's two minutes and forty-one seconds.[62] We believe that Copeland applied a delay effect unequally across the frequency spectrum of the recorded clip, resulting in an echo of speech degraded into the rhythmic sounds of ticks and pops ("The Young-Girl doesn't age. She decomposes").[63] While this reverberative rot gets more pronounced as the track proceeds, the original loop doggedly continues unchanged, as if the Young-Girl were stuck in arrested development while the acoustic architecture responsible for her echo is constantly shifting. "Looking down on the Hot Babe should give you vertigo," Black writes; listening to her does as well.[64] The impact of Copeland's use of audio effects is that the Young-Girl's stubborn assertion that she's worth it, she's worth it, she's worth it becomes more unbelievable as the instability of the shifting standard against which that worth is measured becomes increasingly audible. Perhaps the iterative rhythmic popping in the song is the same as the "clacking" bone percussion Black hears in the Hot Babe's approach to fucking: "She pares sexual relations down to their barest bones and ends up with forms of violence; her laughter rings out in this reliquary, over the orgiastic clacking of bone on bone, and at this extreme, it is only her laughter that stands for 'more life.'"[65]

The Young-Girl laughs. Listen for that later.

61. The connection to *Preliminary Materials* is effectively substantiated in a review that quotes extensively from Tiqqun's text. peer2peer, review of *Because I'm Worth It* by Inga Copeland, Rate Your Music, August 20, 2018, https://rateyourmusic.com/release/album/copeland/because-im-worth-it.p/.

62. trollsofperception, "Inga Copeland—because I'm Worth It," YouTube video, 2:41, August 4, 2014, https://www.youtube.com/watch?v=lXngqUh4MiA.

63. Tiqqun, *Preliminary Materials,* 45.

64. Black, "Further Materials toward a Theory of the Hot Babe."

65. Black.

Fluttering Eyelids

Preliminary Materials's aesthetic of iteration is a major aspect of its textuo-political style, one that asks others to be iterative, too. Or rather, let's go back to the word *provokes*, since *Preliminary Materials*'s appeal is heard not always as a question but sometimes as an aggravation (Tiqqun's anticapitalist contemporary Gilles Châtelet reminds us that "style is not a polite way of thinking").[66] Take Jennifer Boyd's description of Tiqqun's provocation, worth discussing at length:

> Tiqqun make apparent the previously invisible imprint of the Young-Girl upon the body by deploying a tautological didacticism, repeating different versions of the same concept multiple times, relentless conceptual fragments beginning "The Young-Girl is": The Young-Girl is the termite of the "material." Through this tactic, Tiqqun perform the current war as molecular infection, eating the reader alive through these preying mantras. By grinding the reader into the Young-Girl's position of subservience, Tiqqun simultaneously make apparent the presence of the Young-Girl within the reader's own body. This awareness grows as the text develops; as it heightens, Tiqqun can be heard growling, in an undercurrent beneath every word.[67]

While Boyd clearly disagrees with us on one point—we hear Tiqqun's version of the Young-Girl as "her" and "them" and not the "body" of the reader—our interest here concerns Boyd's understanding of iteration as an aesthetico-affective strategy. Iteration, she explains, infects the reader's body through words (preying mantras) and sounds (growls). However, out of this disease comes a reciprocal tactic for resistance, one she details later in her essay, in the form of the "Strange-Girl." The Strange-Girl begins her emergence when iteration devolves into simple, boring repetition—the Young-Girl's

66. Gilles Châtelet, "A Martial Art of Metaphor: Two Interviews with Gilles Châtelet," *Urbanomic,* https://www.urbanomic.com/document/gilles-chatelet-mental-ecology/.

67. Boyd, "A Theory for the Strange-Girl."

wink locked "on repeat." Boom wink boom wink boom wink. This "flutter of the eyelid"—which Boyd likens to "the rhythmic high-tempo cracks of flickering strobe lights"—is actually the choreography of the Young-Girl's death (at least, that's how Boyd imagines it). But the flutter is also the quickening of the Strange-Girl as a formidable force of "ragged rage." The Strange-Girl can finally possess her power when the wink becomes novel once again—when repetition becomes iteration, but an iteration freed from its servitude to both capitalism and "tautological didacticism."[68]

While Tiqqun have trash theory and we have close listening, McKenzie Wark has "thin description." With "thin description, one might not be terribly interested in whether a wink is caused by a tic, an infection, or an intention, but rather that the gesture is communicable across space and time to an observer, who writes it down and communicates it to another, in contexts unknown, far away," she explains.[69] In close listening, this is also true. We are not terribly interested in whether the Young-Girl's wink is *caused by* a tic, an infection, or an intention. However, we *are* terribly interested in the Young-Girl's wink *as an infection* and in the behavior of the infected corporeal and textual bodies that flicker and rage raggedly in response.

68. Ibid.
69. McKenzie Wark, *Telesthesia: Communication, Culture, and Class* (Cambridge, UK: Polity Press, 2012), 11.

2. Orality

Attention should particularly be paid to ways of reading that have been obliterated in our contemporary world: for example reading out loud in its double function—communicating that which is written to those who do not know how to decipher it, and binding together the interconnected forms of sociability which are all figures of the private sphere (the intimacy of the family, the conviviality of social life, the cooperation of scholars [*connivence lettré* [*sic*]]).

—ROGER CHARTIER, *"Laborers and Voyagers: From the Text to the Reader"*

One types the correct incantation on a keyboard, and a display screen comes to life, showing things that never were nor could be.

—FREDERICK P. BROOKS JR., *The Mythical Man-Month: Essays on Software Engineering*

Reading with a Tone

As we've already heard, Megan Arlett considers Tiqqun's "the Young-Girl X, the Young-Girl Y, the Young-Girl Z" to be "a kind of chant."[1] *Chant* is etymologically related to the Old French *chanter,* or "to sing," which is itself likely related to the Latin *cantus,* or "song"; like the words *incantation* and *enchantment* (as well as *cock*

1. Megan Arlett, "A Preliminary Theory on Kissing," *The Pinch*, November 15, 2019, http://www.pinchjournal.com/cnf-blogroll-/2019/11/15/a-preliminary-theory-on-kissing-by-megan-arlett.

and *hen*), *chant* is probably derived from the Proto-Indo-European root *kan-*, which means "to sing."[2] Wiktionary defines *chant* as "a repetitive song, typically an incantation or part of a ritual," and *incantation* as a "formula of words" used to produce "magical results."[3] A network of etymological affiliations ties together chant, enchant-ing, incantation, and cant (jargon, secret language, insincere talk, "the whining or singsong tone of a beggar").[4] Eighteenth-century elocutionists were particularly averse to a "chanting or sing-song voice" known as "reading with a tone."[5] Tough shit, folks.

Jennifer Boyd ends her essay on the Strange-Girl with what she calls an "incantation."[6] She instructs us to repeat it after her. It includes the following:

> *The Strange-Girl is a burnt tongue.*
> *She is too hot to handle (a menace).*
> *She is the rattle of a cage, an asteroid entering the atmosphere.*
> *She is scorched earth.*[7]

We say: She is ___. She is ___. She is ___. Iteration within repetition. Repeat it. Tiqqun's voice of Narcissus is really another Echo.

Michael Jackson wrote a manifesto. He did. "I will," he repeats throughout. "I will." "I will do no interviews/I will be magic./I will

2. "chant (n.)" and "chant (v.)," *Etymonline*, accessed February 25, 2021, https://www.etymonline.com/word/chant#etymonline_v_44063; "*kan-," *Etymonline*, accessed February 25, 2021, https://www.etymonline.com/word/*kan-#etymonline_v_53174.

3. "chant," *Wiktionary*, June 2, 2020, https://en.wiktionary.org/wiki/chant; "incantation," *Wiktionary*, December 1, 2019, https://en.wiktionary.org/wiki/incantation.

4. "cant," *Etymonline*, accessed March 5, 2021, https://www.etymonline.com/word/cant#etymonline_v_53175; "cant," *Dictionary*, accessed February 25, 2021, https://www.dictionary.com/browse/cant?s=t.

5. Patricia Howell Michaelson, *Speaking Volumes: Women, Reading, and Speech in the Age of Austen* (Stanford, CA: Stanford University Press, 2002), 144.

6. Boyd, "A Theory for the Strange-Girl."

7. Boyd.

be a perfectionist/a researcher a trainer/a Masterer/I will be Better than every great/actor roped in one."[8]

For Boyd and for Tiqqun, the philosophical incantation is a provocation to mimesis. Some pedagogical activities can likewise be considered to be attempts to goad listeners, students, in this case, into imitation, although these exercises are not generally understood as magical. Rote recitation of multiplication tables ("Repeat after me, class, five times five is twenty-five"), pronunciation drills, and the dreaded French *dictée* (an old-fashioned but still employed French exercise requiring students to transcribe words spoken aloud by the teacher without spelling or grammar mistakes) all demand that students imitate the performance of an authority, directly or with the added challenge of altering the modality, as in the *dictée*. While the difference between a witchy incantation that invites participation through sensuous entreaty and a school chanting exercise, let's say, at first seems stark, it may not actually be, as the affective, bodily, and social dimensions of group chanting are exactly what are instrumentalized for educational aims. The *dictée* admittedly functions differently; it takes the sociality of collective mimetic enunciation and transforms it into competition, as this kind of writing, like most writing, is a solo affair, and students are assessed on an individual basis. For us, though, as young American students of French (one of us renamed Odile, the other Delphine), the pleasure in the *dictée* arose not from the accuracy of our transcription but from the rhythmic sound of group writing, a collective attack dissolving into noise only to cohere for a moment when a critical mass of small hands moved pencils across paper in almost unison. There is no song in the *dictée,* but there is sometimes a little bit of music (then again, who really likes a *dictée*?).

Preliminary Materials weaponizes the sonorous demands of the incantation for rhetorical and educational purposes. As Jen

8. Qtd. in Julian Hanna, "Manifestos: A Manifesto," *Atlantic,* June 24, 2014, https://www.theatlantic.com/entertainment/archive/2014/06/manifestos-a-manifesto-the-10-things-all-manifestos-need/372135/.

Kennedy notes but does not develop in detail, by describing the operation of the Young-Girl in "textual and sonic terms, Tiqqun disrupt the hegemony of vision in the 'Spectacle,' detaching the Young-Girl from her most prized possession: her image."[9] While we do not understand Tiqqun's project of remediation as, ultimately, enabling, we do want to pick up where Kennedy leaves off in her astute identification of sound—and, by extension, orality—as an instrumental modality of *Preliminary Materials*.

Tiqqun's political strategy mobilizes some hallmarks of orality, such as "heavily rhythmic, balanced patterns, in repetitions or antitheses, in alliterations and assonances, in epithetic and other formulary expressions," to borrow the oft-cited words of Walter Ong.[10] Ong's theory of orality and literacy famously distinguishes between primary and secondary orality, with the former as "the orality of a culture totally untouched by any knowledge of writing or print" and the latter as "a new orality [that] is sustained by telephone, radio, television, and other electronic devices that depend for their existence and functioning on writing and print."[11] This new orality "has striking resemblances to the old in its participatory mystique, its fostering of a communal sense, its concentration on the present moment, and even its use of formulas."[12] Although *secondary orality* has been used to describe networked typographic communication, Ong clarifies in a 1996 interview that *secondary literacy* is a more accurate term, as secondary orality refers literally to technologized *spoken* modes of communication, while secondary literacy is applied to written communication with the "temporal immediacy of oral exchange."[13] Bonnie Stewart's article "Collapsed Publics: Orality,

9. Kennedy, "Young-Girl in Theory," 185.

10. Walter Ong, *Orality and Literacy: The Technologizing of the Word* (London: Routledge, 2002), 34.

11. Ong, 11.

12. Ong, 133.

13. Qtd. in John Walter, "Ong on Secondary Orality and Secondary Literacy," *Notes from the Walter J. Ong Archive* (blog), July 16, 2006, http://johnwalter.blogspot.com/2006/07/ong-on-secondary-orality-and-second-

Literacy, and Vulnerability in Academic Twitter" (2016) makes excellent use of the distinction, providing a potential framework for considering much of networked typographic communication. She argues that the "rhetorical, repetitive uses of language" Ong associates with orality "are evident in phenomena such as internet memes, wherein oral, visual, and textual forms of humor are repeated and circulated."[14] Addressing Twitter, the primary subject of her study, she claims that the platform "increasingly collapses oral and written norms of communication, creating a space wherein the immediate, dialogic exchange of orality is meshed with what boyd calls the persistent, replicable, scalable and searchable qualities of digital content."[15] *Preliminary Materials,* with its iterative, formulaic, and often conversational style, has an oral sensibility at home on platforms of secondary literacy such as Twitter, Reddit, and Facebook, facilitating the manifesto's success on social media.

This erosion of the boundary between writing and word of mouth in the age of networked communication also puts pressure on understandings of spoken language. To clarify, as we argue in "Gossip Girl Goes to the Gallery," "the early adoption of text messaging and chat technologies by many young people has generated a new stereotype of teen language as improperly visual" and of improperly visual speech as adolescent. We continue,

> specifically, the shorthand used in Instant Messaging (IM) (such as FML and LMAO) and social networking has entered spoken language. Such locutions play a powerful role in vernacular definitions of girl talk as vacuous, mockable yet discomfiting, always-already shared (and thus failing to index autonomous subjectivity) and in-

ary.html. We believe the original citation is indeed the following, although we could not locate this publication: M. Kleine and F. Gale, "The Elusive Presence of the Word: An Interview with Walter Ong," *Composition FORUM* 7, no. 2 (1996): 65–86.

14. Bonnie Stewart, "Collapsed Publics: Orality, Literacy, and Vulnerability in Academic Twitter," *Journal of Applied Social Theory* 1, no. 1 (2016): 73.

15. Stewart, 64.

herently digitextual. Words like OMG, although they are used by both men and women in response to a juicy bit of information, have come to stand for girl talk writ large and are convenient symbols of girls' linguistic impressionability.[16]

Par for the course is the "sksksksk" that dominates the speech of VSCO girls, a teen persona strongly associated with "a language, created from viral memes and internet expressions."[17] The alternation of "s" and "k," originally a kind of keyboard smash likely first used on Black Twitter (a debt to Black vernacular that should be acknowledged across memetic internet culture), indicates a reaction of heightened emotion and is similar to OMG or "I can't even."[18] VSCO girls are derisively identified by their love of big T-shirts, scrunchies, saving the turtles, and vocalizing this typographic response in everyday oral conversation. Numerous caricatures of VSCO girls can be viewed on YouTube and TikTok in which their "sksksk" is repeated to absurdity. VSCO girls could be the daughters of former Valley Girls, whose Valspeak sociolect included Zlint, the phonetic pronunciation of Xlnt, an abbreviation used in print classified ads.[19] If the oral textuality of social media is often dismissed as the feminized and juvenilized blather of "global village gossip," to borrow a phrase from Giselle Bastin, the typographic orality of textspeak also has a strong association with adolescence and

16. Warren-Crow, "Gossip Girl Goes to the Gallery," 112.

17. Chelsea Ritschel, "VSCO Girl: Where Did 'And I oop' and 'sksksk' come from?," *Independent*, November 25, 2019, https://www.independent.co.uk/life-style/vsco-girl-and-i-oop-sksksk-meaning-tiktok-instagram-save-the-turtles-a9123956.html.

18. Lauren Strapagiel, "Like Most Slang, 'Sksksksk' Originated in Black and LGBTQ Communities," *BuzzFeed*, August 29, 2019, https://www.buzzfeednews.com/article/laurenstrapagiel/this-is-why-vsco-girls-keep-saying-sksksksk. For information on blackness and internet culture, see Laur M. Jackson, "The Blackness of Meme Movement," *Model View Culture*, March 28, 2016, https://modelviewculture.com/pieces/the-blackness-of-meme-movement.

19. "American Slang: Valspeak," *Language Dossier*, https://language-dossier.webs.com/americanslangvalspeak.htm.

femininity.[20] Like consumption, a practice of all genders and nearly all ages that has historically been understood vis-à-vis discursive constructions of femininity and adolescence, the collapse of oral and written norms of communication is often *girled*.

More specific to our point, *Preliminary Materials*'s integration of orality and literacy is directly related to its critique of the feminized consumption of commodities, especially in consideration of the text's quotations from women's fashion and beauty periodicals. These magazines tend to hail their readers through the aurality of words, following conventions established in advertising prior to Web 2.0. To wit, this "advertising style" is a hallmark of the globalized *Cosmopolitan* magazine franchise, according to David Machin and Theo van Leeuwen's analysis of the "linguistic style" of articles from forty-four versions of *Cosmo* in 2001, including U.S., Dutch, Spanish, Indian, and Chinese publications (here style is not its political attributes or the characteristic voice, tone, and form of an author's work but the standardized house style of a particular publication).[21] The authors conclude that the *Cosmo* brand's globalized style of writing is an aggregate that includes an imitation of "advertising style," with its "direct address," "ear catching language," and "use of rhyme and alliteration."[22] *Preliminary Materials* incorporates the rhythmic, sonorous entreaty of the language of advertising through quotations from magazines (and actual advertisements), while also using advertising style as an operation performed on other parts of the text. The self-professed trashiness of the theory is related not only to its disjointed rhetoric but also to its reperformance of the oral-aural literacy of advertising.

20. Giselle Bastin, "Pandora's Voice-Box: How Woman Became the 'Gossip Girl,'" in *Women and Language: Essays on Gendered Communication across Media,* ed. Melissa Ames and Sarah Himsel Burcon (Jefferson, N.C.: McFarland, 2011), 18.

21. David Machin and Theo van Leeuwen, "Language Style and Lifestyle: The Case of a Global Magazine," *Media, Culture, and Society* 27, no. 4 (2005): 578.

22. Machin and van Leeuwen, 588–92.

Some respondents to *Preliminary Materials* investigate the collapse of oral and written norms of communication by presenting the Young-Girl as a zone of conflict between linguistic modes. For example, take the Bureau de L'APA's theatrical rejoinder to *Preliminary Materials, Death and the Jeune-Fille* (*La Jeune-Fille et la Mort*, 2010), which premiered in Québec City, Canada, and has since been performed at EMPAC at the Rensselaer Polytechnic Institute in Troy, New York, and the Espace Libre theater in Montréal.[23] Billed as "Based on Tiqqun" ("D'Après Tiqqun"), *Death and the Jeune-Fille* puts *Preliminary Materials* into relation with Franz Schubert's prior invocation of female youth, the 1817 song known in English as "Death and the Maiden" (called "La Jeune-Fille et la Mort" in French), the theme of which he recycled for the second movement of his String Quartet no. 14 in D Minor seven years later.[24] Following *Preliminary Materials,* which makes multiple references to death (for a cute illustration, check this out: "she is the slut who *demands* respect, death roiling in itself, she is the law and the police at the same time"), the Bureau de L'APA cross-reference mortality and capitalism by interweaving a performance of this quartet with excerpts from *Preliminary Materials* voiced by actors.[25] Speaking of mortality and capitalism: a manifesto from the Angry Brigade, written to claim responsibility for the 1971 bombing of a Biba boutique in London (no injuries or deaths), proclaims, "If you are not busy being born you are busy buying."[26] An address to the ear, the blackest of humor, a serious joke. As part of their critique of capitalism,

23. Le Bureau de L'APA, "Death and the Jeune-Fille," https://www.bureaudelapa.com/en/projetsliste-apa.php; "La Jeune-Fille et la Mort (Death and the Young-Girl)," *EMPAC,* 2013, https://empac.rpi.edu/events/2013/la-jeune-fille-et-la-mort-death-and-young-girl.

24. Le Bureau de L'APA, "La Jeune-Fille et la Mort (Death and the Young-Girl)," video recording of performance, Experimental Media and Performing Arts Center, Troy, N.Y., October 2013.

25. Tiqqun, *Preliminary Materials,* 141.

26. Angry Brigade, "Biba's Was Bombed," *International Times* 1, no. 104 (May 19, 1971), 5.

the Angry Brigade complain that shop girls were forced by Biba branding in 1971 to wear lewks suggesting the 1940s, for "capitalism can only go backwards—they've got nowhere to go—they're dead."[27]

In the "trash dramaturgy" of *Death and the Jeune-Fille,* Tiqqun's theory serves as an unconventional playtext delivered piecemeal—spoken aloud (sometimes by one actor ventriloquizing another), projected on an upstage scrim, written on the bodies of performers in black marker and on paper grocery bags worn on their heads.[28] Fragments of *Preliminary Materials* are included in a booklet given to audience members at the top of the show. The performers, as well as the projection, direct the audience to specific page numbers so readers can participate in what is framed as a lesson about the Young-Girl. The conceptual persona of the Young-Girl emerges between multiple modalities: between projected typography, printed text, handwritten words, and spoken language; between the book on the audience's laps and the text exhibited onstage; between reading and listening; between the meaning of words and their sound. Better yet, the Young-Girl of the play is born of the repeated collapse of different modes of communication. Although the scenography suggests a schoolhouse from the early or mid-twentieth century, the show's obsession with an uncomfortable confrontation of orality and literacy (reading the book on one's lap makes following the action on stage difficult, for example) allows for the secondary literacy of both *Preliminary Materials* and communication over social media to be felt, deeply, without obvious markers of youth, girliness, or the World Wide Web.

As we argue in this chapter, the "outlouding" of theories of the Young-Girl onstage, onscreen, and in galleries activates a relationship between femininitude, youthitude, and sound latent in *Preliminary Materials.*[29] The Young-Girl is animated in these per-

27. Brigade.

28. Alexandre Cadieux, "Trash dramaturgie," *Le Devoir,* October 17, 2012.

29. aqnb, "YGRG's Outlouding of Words + Intimacy in 14x Performance 'Reading with a Single Hand' at Baltic Triennial," December 8,

formances as a fraught interface between orality and literacy in the age of "communicative capitalism" and the networked media on which it relies. Jodi Dean identifies communicative capitalism as a political, economic, and social formation in which "communication has become a primary means for capitalist expropriation and exploitation" and networked participation magics users into "feel[ing] that action online is a way of getting their voice heard, a way of making a contribution."[30] While Dean is using voice to mean an individual's point of view, the various vocalizations of the Young-Girl we discuss in this chapter mobilize both metaphorical and literal understandings of voice to ask questions about action, agency, commodification, and the nature of networked communication. Many of these artists and other creators have more hope for the political value of the voice on social media than Dean's argument affords, and yet communicative capitalism remains a useful reference point for theories of the Young-Girl writ large.

As will later become clear, the Young-Girl's voice provides an opportunity to hear the capacity of voices to become *technologies* of both enabling and disempowering modes of political subjectivity. Let's take seriously the fact that "the human voice" was recently named technology of the year by *MIT Sloan Management Review* in an article that considers the rise of digital assistants, text-to-speech conversion, and podcasting.[31] When the voice, or, rather, voices of the Young-Girl become audible—sometimes mocked, sometimes inscrutable, sometimes contagious, sometimes looped, sometimes

2017, https://www.aqnb.com/2017/12/08/ygrgs-outlouding-of-words-intimacy-in-14x-performance-reading-with-a-single-hand-at-baltic-triennial/.

 30. Jodi Dean, "Communicative Capitalism and Class Struggle," *Spheres: Journal for Digital Culture* 1 (2014): 4; Dean, "Communicative Capitalism: Circulation and the Foreclosure of Politics," *Cultural Politics* 1, no. 1 (2005): 61.

 31. Paul Michelman, "Why the Human Voice Is the Year's Most Important Technology," *MIT Sloan Management Review,* January 20, 2017, https://sloanreview.mit.edu/article/why-the-human-voice-is-the-years-most-important-technology/.

rejected, sometimes shared, sometimes hesitant, sometimes in your face, sometimes, let's say, Britney, sometimes Kardashian, sometimes even queer—a political subject can be heard.

Notably, the voice that opens *Death and the Jeune-Fille* does not sound Britney, Kardashian, or queer. This is the voice of a character identified in the program as the Professor, an older, white, patriarchal authority. At the top of the show, he calls himself "your teacher of French as a foreign language," stands in front of the audience, and gestures for them to write while he speaks, to do a *dictée*. The audience in the video documentation of the performance instead orally repeats what he says; they aren't given time to get out pens, or maybe they missed the actor's brief hand gesture. There is a single sentence in the recitation: "The Young-Girl is not there, period" ("La Jeune-Fille n'est pas là, point final"; *là* means "here" or "there," although the version of the show performed in New York translated it only as "there"). The audience chants, incants together, this formula of words. With each repetition, the Professor replaces more words in the sentence with *là*. "La Jeune-Fille n'est là là là là là." The *là*s are laid over replaced words, and by the end of the run, it's nothing but sung *la la la lalala*s, a cartoonish onomatopoeia for singing, articulated with roughly the same rhythm as before—bafflegab said with patriarchal conviction. From the rhythm of his speech, a melody soon emerges, blending with the eponymous Schubertian melody picked up by the string quartet throughout the show. In solfège, a method for ear training for musicians, "A" is "La." This is part of the joke.

The Professor's statement loses meaning as the exercise proceeds. It devolves into lalalalaland. This unraveling is suggestive of popular complaints regarding product iteration. Relentless versioning can sometimes result in a series of downgrades in product performance, a process that the urban dictionary gives the apt name "shiteration."[32] The professor shiterates the fuck out of that

32. *Urban Dictionary*, s.v. "shiterate," January 18, 2018, https://www.urbandictionary.com/define.php?term=shiterate.

sentence—semantically, that is, because while speech loses force by degrees, voice continues to perform the lesson, empowered. The Professor walks offstage, still singing. He directs his melody toward the sitting string quartet on his way out, as if to prompt them to respond musically.

In this scene, the decomposition of meaning (and of the disciplinary power of pedagogy) transforms his professorial lecture into a musical composition. However, we do not hear this strategy as one of liberation. Instead, *Death and the Jeune-Fille* repeatedly swaps one kind of power over subjects with another, staging and restaging, obsessively, a shift between disciplinary societies and societies of control. In Gilles Deleuze's "Postscript on the Societies of Control" (1990), he distinguishes between the power to "*mol[d]*" subjects in disciplinary societies of the eighteenth through twentieth centuries and the power to "*modulat[e]*" subjects continuously in the societies of control that had begun to replace them.[33] We might consider the outmoded classroom we see onstage in *Death and the Jeune-Fille*, with its wooden flip-top children's desks and attached chairs, as a reference to the school as a model space of enclosure in the theory of disciplinary societies Deleuze borrows from Michel Foucault. In a remarkable moment of the play, a hidden mechanism is activated that motorizes the flip-tops of the wooden desks, turning the furniture into idiophonic percussion instruments collectively banging out a rhythm. Here the archetypical architecture of enclosure loses its function to shape and organize bodies logically and efficiently. The schoolhouse loses, turns into something other than itself (as the Professor loses), but it also gains: it gains rhythm, musicality. It loses the ability to mold and gains the ability to modulate. Modulation is particularly resonant in our context, as it can refer to three kinds of change—the modification of an element of music (usually key, but

33. Gilles Deleuze, "Postscript on the Societies of Control," *October* 59 (Winter 1992): 4.

possibly timbre or pitch), the variation of the musical qualities of the voice, and the fluctuation of an electromagnetic signal.

The concept of the Young-Girl, which the performers attempt to teach audiences throughout the play using different tactics, is a kind of machinic relay between different modalities of power. Indeed, we could understand the play's use of the Young-Girl as challenging any idea that the process of substituting control for discipline became a done deal sometime between the 1990s, when Deleuze's "Postscript" and Tiqqun's *Preliminary Materials* were first published, and the Bureau's production. In *Death and the Jeune-Fille,* this shift between old school and new school (between authoritative patriarchal speech and the euphony of song, between furniture and percussion instrument, between handwriting words and projecting typography) happens again and again throughout the course of the play. *Death and the Jeune-Fille* is a theory of subjectivity haunted by a past that will not stay dead and driven by the musicalized, modulated, and remediated rhythms of uncanny repetition.

The Bureau de L'APA's production considers issues of subjectivation alongside those of communication. As the relay between discipline and control, the Young-Girl is neither one nor the other. She is also not in speech *or* writing, not in the writing that should have been (the audience's failure to do the *dictée) or* the writing that is (on actor's bodies), not then *or* now, here *or* there, but in our destabilizing efforts to connect the here and there of orality and literacy and our conflicting desire to decouple them, to reverse the collapse. In this way, *Death and the Jeune-Fille* is more doggedly focused on communicative capitalism than is its textual inspiration. *Death and the Jeune-Fille* is also about what McLuhan calls the "Verbi-Voco-Visual Explorations" possible in acoustic space, and the function of *Preliminary Materials* as an acoustic political text that activates those possibilities, as anxious and/or enabling as they are.[34] Indeed, *Preliminary Materials* is a vicious playground

34. Marshall McLuhan, *Verbi-Voco-Visual Explorations* (New York: Something Else Press, 1967).

for Verbi-Voco-Visual Explorations, and one of its greatest or most troubling successes, depending on your assessment of its misogyny, is its politicization of the game of secondary literacy that many of us know so well.

WTF, Robo-Hamster?

She may not ultimately be there, period ("point final," says the Professor in *Death and the Jeune-Fille*), but the urge to speak of and as the Young-Girl is very strong. A number of video responses to *Preliminary Materials* vocalize text taken from the manifesto, such as YouTube user Carlos's "Introduction to a Theory of the Young Girl" (2009), which emphasizes the gendered and aged attributes of the model citizen-consumer by alternating the deep, stereotypically masculine voice of a narrator speaking quotations from the manifesto with the seemingly semi-improvised chitchat of a blonde Young-Girl vapidly expositing on clothing and boyfriend choices.[35] The narrator's voice functions as a film "commentator-acousmêtre" as identified by Michel Chion; the narrator is the all-powerful voice without a visible body, the voice of knowledge and authority, "he who never shows himself but who has no personal stake in the image."[36] This voice performs in stark contrast to the one attached to the visible body of the Young-Girl, whose body has a personal stake in the image because it is a *body-as-image*. While the narrator is everywhere and nowhere, the Young-Girl is fixed within the

35. Carlos, "Introduction to a Theory of the Young Girl," YouTube video, 5:12, June 11, 2009, https://www.youtube.com/watch?time_continue=160&v=BAKGEXQUymo.

36. Michel Chion, *The Voice in Cinema* (New York: Columbia University Press, 1999), 21. Elsewhere in the book, Chion contradicts himself by saying that this kind of voice-over narration is not an acousmêtre, which requires that the speaker in question, "even if only slightly, have *one foot in the image*, in the space of the film." Nonetheless, the description of the power of the disembodied voice of the narrator of "Introduction to a Theory of the Young Girl" still holds (24).

frame, usually doubly confined within the tight domestic spaces of her bedroom and living room, where she is shown prattling away (as we are asked to judge her girl talk). When the Young-Girl is momentarily silent, she is either typing on her laptop or scrolling on her phone, a remediation of her irritating vocal profligacy into digital textuo-gesturality.

A more literal speaking aloud of *Preliminary Materials* is YouTube user Ned Ludd's video audiobook, broken into eleven parts, each with a still image as a visual placeholder paired with Ludd's low-pitched speaking voice. Ludd's collection of video audiobooks was all uploaded in 2015. His channel features the eleven-part *Preliminary Materials* as well as the three-part *Desert* (2011), written by an anonymous anarchist, and a mocking rendition of anarchist John Zerzan's essay "Why I Hate Star Trek" (2002).[37] Ludd's reading of *Preliminary Materials* is interesting to us in the modesty of its claims: not an interpretation or even introduction but a transduction of modality from text to speech. The simplicity of this approach allows us to apprehend aspects of the orality of a Young-Girl theory in its most bare form.

Ludd takes his pseudonym from the storied leader of the Luddites, early nineteenth-century protesters of exploitative labor practices in Britain. Smashing the textile machines they operated as a way of battling their oppressive employers (and not out of a general resistance to technology, as is usually designated by current usage of the moniker), many Luddites wrote letters, manifestos, and songs signed with the name of Ned Ludd, protecting the true identity of the authors while embracing the shared persona of a Robin Hood–type folk hero.[38] Ned Ludd is what Marco Deseriis calls "an

37. Ned Ludd, "Ned Ludd," YouTube channel, https://www.youtube.com/channel/UCScm9u8imX-988B0QGlNUtw/videos.

38. Those interested in the songs, letters, and other writings attributed to Ludd and the name's iterations, such as General Ludd, Edward Ludd, King Ludd, and Eliza Ludd, should check out Kevin Binfield, *Writings of the Luddites* (Baltimore: Johns Hopkins University Press, 2004).

improper name," "the adoption of the same alias by organized col-
lectives, affinity groups, and individual authors."[39] "Tiqqun" can
also be considered an improper name; it performs "the shielding
effect of any pseudonym" while acting "as an open multiplicity that
can hardly be disambiguated and assigned a discrete referent."[40]
The improper name establishes this indiscrete referent as neither
the collective enunciator of the We (as in "We the People") nor the
individual utterer of the I but both, "recombin[ing] the I and the We
in a highly unstable, elusive assemblage."[41] Deseriis proposes an iso-
morphic relationship between the impropriety of such names and
"the impropriety of Internet memes—such as catchphrases, image
macros, viral videos, and Web celebrities." "Situated at the intersec-
tion of the collective imagination" and "authorless yet discrete" "it-
erations," memes are the products of, for the most part, anonymous
and pseudonymous internet users.[42] Although there are obvious
differences between the Luddites' "collective bargaining by riot,"
the original publication of *Preliminary Materials,* and this YouTube
user's recordings of texts associated with anarchism, what joins
these three utterances and historical moments is the performance
of political subjectivity as a faceless but not voiceless articulation.[43]

As Ludd explains his YouTube oeuvre, "I read in my monotone
voice.... Ask youself [*sic*] now, what the hell am I doing here, watch-
ing this boyo's videos? That's for you to decide, fellow anomie."[44]

39. Marco Deseriis, *Improper Names: Collective Pseudonyms from the
Luddites to Anonymous* (Minneapolis: University of Minnesota Press, 2015),
"Introduction: Genealogy and Theory of the Improper Name," Kindle.
 40. Deseriis, "Introduction."
 41. Deseriis, "Introduction."
 42. Deseriis, "Introduction."
 43. E. J. Hobsbawm, "The Machine Breakers," *Past and Present* 1,
no. 1 (1952): 66. While Ludd's YouTube channel has a profile pic of a face,
a thumbnail rendered in hypercolor with a green percentage sign on the
bottom edge, this is not necessarily his own face, given the profile pic con-
ventions of YouTube, nor is the face very legible. Regardless, the audiobook
videos do not have visuals of Ludd reading. The reader remains in the dark.
 44. Ned Ludd, "About," YouTube channel, https://www.youtube.com/
channel/UCScm9u8imX-988B0QGlNUtw/about.

The voice in these videos *is* fairly monotonous, for the most part, except when he reacts to stumbling over a word—undoubtedly accidental, but with the effect of reminding the listener that Ludd is *reading* words, and words that are not his own—and when the persona of the Young-Girl intervenes in the staid narration. Those Tiqqun quotations pulled from fashion magazines and advertising are read differently than the rest of the text: in a high, digitally pitch-shifted voice sped up to the point of near-complete unintelligibility (a techno-amphetamine shot that disorders the speaker's poorly put-on Valley Girl rhythms and broad pitch variations as a parody of girl talk). "Since the Young-Girl is a horrifying sociological construct," Ludd clarifies in a comment on one of the videos, "I decided to make it sound as inhuman as possible, in order to reveal the true voice of the Spectacle that speaks through human beings."[45] This Young-Girl—Ludd, himself, we assume, with an altered voice, but it's impossible to know for sure—sounds a bit like a kidnapper, terrorist, or hacker using a voice-disguising application on a telephone call. The rough, off-rhythm digital insertion of these sequences into the recording exaggerates the Young-Girl's criminal effect, as if she'd forced herself into the private space of the boyo's narration. In cahoots with the voice's machinic timbre and speed, such shoddy digital cut and paste makes audible the "Young-Girlist formatting" Tiqqun decry as a weapon and effect of late capitalism.[46]

Following the logic of the typical audiobook, we wager that the anthropotechnical squawk of the Young-Girl is indeed Ludd's voice transformed past the point of identification. Thus, by producing what could be called the oral-aural sound of irony, Ludd solves the "problem" of having the masculine voice of authority vocalize girly exhortations from magazines and advertisements. Perhaps he also

45. Ned Ludd, comment on Ned Ludd, "Preliminary Materials for a Theory of the Young-Girl: The Young-Girl as Phenomenon," YouTube video, 23:54, January 19, 2015, https://www.youtube.com/watch?v=pMZM-WrRmh88.

46. Tiqqun, *Preliminary Materials*, 19.

just couldn't say "Because I'm worth it!" with a straight face, unlike Inga Copeland. Regardless, the very ridiculousness and artificiality of that speech denaturalize the Young-Girl (compare Ludd's choice to what we hear in Carlos's video, in which the chirpy Young-Girl is played by an actress in her late teens or twenties). Of course, Tiqqun insist that the Young-Girl is not the same as young girls and that qualities of femininitude and youthitude have been dislodged from the sexed and aged bodies of young women and transmitted across populations. The Young-Girl is not a gendered concept, and she is not a natural-born killer. OK. However, the attributes of the Young-Girl are clearly *gendered forces,* and the gendering of those forces is bodied forth in the text through overdetermined references to fashion, makeup, magazines, consumption, eating disorders, narcissism, and other things strongly associated with discursive constructions of young women. In the case of Ludd's Young-Girl voice, whatever forces that have transformed it are so alien that they obscure Ludd's lackadaisical attempt at performing the vocal rhythms of the Valley Girl stereotype. The Young-Girl is heard, but not as young or as a girl.

Moreover, what is utterly clear in these sound bites *on the page*— after all, advertising generally aims to be a direct and memorable form of address, and Tiqqun have not chosen quotations that veer away from this trend—is magicked into something weird and disruptive *in its audio form.* Although we might understand this voice's lack of girliness and youth as simply an attempt to materialize Tiqqun's statement that, for the Young-Girl, "what is most 'natural' is most feigned, what is most 'human' is most machine-like" (an understanding supported by Ludd's explanation), *at the same time,* Ludd's manipulated voice is so unclassifiable and illegible as to obscure, almost completely, the provenance of those quotations, especially for those who haven't already read them on the page.[47] We played this audiobook for our partners, and they said "what was that?" every time the robo-hamster hacked into the narration (we

47. Tiqqun, 26.

chose the hamster out of all rodents because of its presence in the Anglophone and Francophone manosphere as a symbol of women's stupidity and self-delusion). We, who know the book so well, were forced to pause the video and translate. Whose (or what's) voice are we hearing, and WTF is it saying?

The question of whether to own, disown, or disavow the voice of the Young-Girl is a deeply political one, especially considering the broad metonymic understanding of voice as an "instrument or medium of expression," "wish, choice, or opinion openly or formally expressed," and "influential power" in public discourse.[48] Canadian video artist Madelyne Beckles has a provocative response: let's *disidentify*. In Beckles's *Theory of the Young-Girl* (2017), a kind of winking "PSA about feminist theory" inspired by growing up during the heyday of "Lindsay Lohan, Paris Hilton," the artist articulates the Young-Girl's textual exhortations as if they were her own.[49] However, she simultaneously distances herself from the Young-Girl's vacuity by performing the quotations with half-assed actorly conviction and exaggerated vocal fry—the Kardashian grumble heard when the voice descends into its lowest register, often at the end of an utterance. More specifically, Beckles gives us a vocal performance that disidentifies. José Esteban Muñoz defines disidentification as a strategy for minoritarian subjects (like Beckles) who reperform and rework received representations through neither capitulation nor rejection. Certain kinds of parodic performance can mobilize a "disidentificatory desire for this once toxic representation"—in our case, the Young-Girl.[50]

48. *Merriam Webster*, s.v. "voice," https://www.merriam-webster.com/dictionary/voice.

49. Madelyne Beckles, "Theory of the Young-Girl," YouTube video, 4:20, July 21, 2017, https://www.youtube.com/watch?v=Z9TdD7SG8HQ; Amanda Parris, "'Feminism Is the New Black!' Why One Artist Pokes Fun at Feminist Theory and Performative Activism," CBC, January 25, 2018, https://www.cbc.ca/arts/feminism-is-the-new-black-why-one-artist-pokes-fun-at-feminist-theory-and-performative-activism-1.4504210.

50. José Esteban Muñoz, *Disidentifications: Queers of Color and the Performance of Politics* (Minneapolis: University of Minnesota Press, 1999), 3.

A speech artifact strongly associated with young North American and British women and other feminized people (even though it can be heard from cis het men as well), vocal fry is worth discussing at greater length. Naomi Wolf describes the sound as "that guttural growl at the back of the throat, as a Valley girl might sound as if she had been shouting herself hoarse at a rave all night" in a clutch-the-pearls op-ed that accuses an entire generation of women of "disowning [their] power." The "non-committalness" of this sound is heard in contrast, by implication, to the alleged strength, confidence, and commitment of the voices of "older feminists" like Wolf.[51] Wolf's screed was published during a period of collective *Home-Alone*-face (so many palms on cheeks) following the publication of a study that claims that young women with vocal fry are less hirable as well as a general backlash against the increasing variation of speaking voices heard on the radio. The voice of authority supposedly speaks with "maturity and confidence"—white, male, and without classed regional affiliations, according to the archetype (#PubRadioVoice), or at the very least an older white woman like Wolf.[52]

The girly sound of vocal fry is extended to typographic communication in the article "How to Tweet Like a Girl," which claims that "expressive lengthening" of words by female Twitter users remediates the "decidedly feminine tic of draaaaagging words out in the back of your *throaaauuttt*."[53] Although author Kat Stoeffel relishes the squandering of letters, it is likely that girlphobic Twitter users would perceive the same irritating noncommittalness in vocal fry's written counterpart (not to mention the erosion of orality

51. Naomi Wolf, "Young Women, Give Up the Vocal Fry and Reclaim Your Strong Female Voice," *Guardian,* July 24, 2015, https://www.theguardian.com/commentisfree/2015/jul/24/vocal-fry-strong-female-voice.

52. Liana Van Nostrand, "Sounding Like a Reporter—and a Real Person, Too," NPR, August 7, 2019, https://www.npr.org/sections/publiceditor/2019/08/07/749060986/sounding-like-a-reporter-and-a-real-person-too.

53. Kat Stoeffel, "How to Tweet Like a Girl," *Cut,* February 19, 2013, https://www.thecut.com/2013/02/how-to-tweet-like-a-girl.html.

and literacy characteristic of VSCO girls). Before explaining that Valspeak *R*s are slurred, rolled off the tongue, Moon Unit Zappa demonstrates the gum chewing of a Valley Girl as first a stretching of the wad, next a wrapping of it around her finger, and then finally a bite and a drawing of her finger away from her mouth.[54]

The discursive relation between girly voices and insecurity is very strong, recalling the work of Gilles Châtelet, one of Tiqqun's Francophone anticapitalist brethren. Châtelet's incendiary political manifesto *To Live and Think Like Pigs: The Incitement of Envy and Boredom in Market Democracies* (1998) has its own version of the Young-Girl, the gendered conceptual persona of the "Bécassine," whose "unseemly, confused stammering" indexes capitulation to exploitation by market democracies.[55] Châtelet's Bécassine is based on an instantly recognizable caricature in French and Franco-Belgian culture that originated in 1905 as an illustration in the young girls' magazine *La Semaine de Suzette*: a provincial young nanny from Brittany named Bécassine (after the French *bécasse,* slang for "silly fool" or "stupid woman").[56] Soon after her debut, she becomes the protagonist of a comic strip that runs until 1962 and the inspiration for frequent adaptations.[57] Châtelet reincarnates Bécassine for

54. Thompson, "Moon Unit Zappa Full Show."
55. Gilles Châtelet, *To Live and Think Like Pigs: The Incitement of Envy and Boredom in Market Democracies* (New York: Sequence Press, 2014), 102.
56. "bécasse," *Larousse,* http://www.larousse.fr/dictionnaires/francais/bécasse/8550?q=bécasse#8496.
57. Lise Tannahill, "Bécassine, a Bande Dessinée Pioneer," *Studies in Comics* 7, no. 2 (2016): 222. In 1979, the comic strip character inspired a corny pop song sung by Chantal Goya that rose to the top of the charts and has become part of a recognized cultural refrain. Ina Chansons, "Chantal Goya, 'Bécassine,'" Archive INA, YouTube video, 2:42, March 7, 2016, https://www.youtube.com/watch?v=HC-sJ1TDZRg. The adaptations get political too. The spin-off character Pencassine has recurring appearances on the parody puppet show *La Bébête Show* as a mashup of the original Bécassine and the far-right politician Jean-Marie Le Pen. Benjamin Bayart, "Discours de Pencassine (remix)," YouTube video, 3:22, December 17, 2014, https://www.youtube.com/watch?v=kPG_r72HD60. The treatment of the Bécassine character has continually sown discord, most recently ahead of

the turn of the century as Bécassine Turbo-Diesel (Turbo-Bécassine, or Neo-Bécassine, for short).[58] This new Bécassine—in a dizzying line of reasoning, identified as the product of petroleum extractivism, automobility and its privatization of public space, the "ludic cyber-melting-pot of money, the city and democracy," and a ridiculous obsession with "fluidity and networks"—rejects the radical politics of her mother, whom Châtelet dubs Bécassine Pétroleuse.[59] However, Bécassine Pétroleuse and other revolutionaries of 1968 are also at the receiving end of Châtelet's unrelenting ire, which takes aim at the Left's role in "the slow putrefaction of *liberatory* optimism into *libertarian* cynicism."[60] The thing both generations of Bécassines share, Châtelet explains, is their inability to stand for anything without a qualifying hesitation, expressed through a verbal tic. What is given to us as a Valley Girl "y'know, like" in Robin Mackay's English translation is better translated as "well . . .

a 2018 film by Bruno Podalydès, when Bretons called for a boycott because of the way they are portrayed as backward and simple. Bruno Podalydès, *Bécassine* (Why Not Productions, 2018). Bécassine and her role as village idiot remain a contested version of provincial Frenchness, while also unveiling a more sinister aftershock of anti-immigrant France. INA France, "Bécassine, l'héroïne de la discorde," video, 2:57, June 20, 2018, https://www.ina.fr/video/S737685_001/becassine-l-heroine-de-la-discorde-video.html.

58. Bécassine Turbo-Diesel has a partner in crime as she party-hardies for the free market: Cyber-Gideon (also called Gideon Cyber-Plus), named after a noodle-necked cartoon duck from the 1970s exported from France to the United Kingdom. In fact, Turbo-Bécassine usually appears in Châtelet's screed with her male partner, who is equally condemnable. It is here that *To Live and Think Like Pigs* deviates from its contemporary relative, *Preliminary Materials*. Despite a similar commitment to the gesture of personification and to a freewheeling, affectively oriented writing style, *To Live and Think Like Pigs* directs its rhetoric at more than one conceptual persona. In other words, while Châtelet does gender his antagonists, he does not situate danger neatly within the feminized. Châtelet, *To Live and Think Like Pigs,* 99–112.

59. Châtelet, 104, 107.

60. Châtelet, 3.

I mean . . ."[61] Yes, the Bécassines might say, but then they quickly sputter into "well . . . I mean . . . ," unable to commit to anything, let alone true political action. Here not even the "older feminists" Wolf might associate with vocal confidence escape critique. Their quavering female voices betray an inner turpitude. Fuck 'em all, Châtelet shouts into a foul wind.

The aesthetic affinity between the "unseemly, confused stammering" of Châtelet's Bécassines and the rumbling, hyperbolic vocal fry of Beckles's Young-Girl can be felt in a video response to *Preliminary Materials* by Solarist Projects.[62] Here quotations from Tiqqun's manifesto overlay a mashup of two viral videos of different groups lip-synching to Carly Rae Jepsen's global megahit "Call Me Maybe" (2012).[63] An unofficial music video of female cheerleaders mouthing the words to Jepsen's track and a reenactment video of male, often shirtless soldiers imitating the cheerleaders are edited together in disorienting oscillation. While the original call-and-response viral exchange is supposed to be funny—men stationed in Afghanistan ape the come-hither gestures of bikini-clad Miami Dolphins cheerleaders—Solarist Projects's mashup is nauseating. As a sonic analogue to the rapid-fire flashing effect created by alternating between brief shots of cheerleaders and brief corresponding shots of soldiers, Jepsen's once sweet voice is given a grating staccato techno-stutter dra-a-a-a-a-gg-ing out the song. This new "Call Me Maybe" sonifies the qualifying hesitation of the song's title and lyrics—Jepsen repeatedly insists that a hottie should call her . . .

61. Châtelet, 102–3. In the original French, the quote is "oui, enfin j'veux dire." Gilles Châtelet, *Vivre et penser comme des porcs: De l'incitation à l'envie et à l'ennui dans les démocraties-marchés* (Paris: Exils Éditeur, 1998), 93.

62. solaristprojects, "Call Me Maybe," YouTube video, 6:36, April 12, 2013, https://www.youtube.com/watch?v=keCUUZKAj5k.

63. Both videos are edited together differently (side by side) in this video: YouTube Multiplier, "Call Me Maybe—Miami Dolphins Cheerleaders vs US Military," YouTube video, 3:20, January 18, 2013, https://www.youtube.com/watch?v=O7zdr-82WAo.

maybe (a "well . . . I mean . . ." if we've ever heard one)—and grossly exaggerates the irritating noncommitalness Wolf hears in vocal fry. It transforms a well-oiled melody into glitchy disjointed phrases through a poiesis and rhetoric of fragmentation, reminding us that "communicative capitalism fragments thought into ever smaller bits," a process generally masked by metaphorical understandings of voice as coherent self-expression.[64] Jepsen's voice is now sliced, diced, deep fried . . . and we can't even dance to it.

The mashup also fries its source videos, moving so quickly between the original call and the soldiers' response that the supposedly clear distinctions between hot babe and military man, bikini and fatigues, dance squad and martial squad, pool patio and tank, ball pit and sand dune, no longer hold. "Seduction as war," the video explains, quoting Tiqqun through textual overlays, "the magazine of my body." Its tempo may have slowed, but the instrumental rhythm of the song marches on, while image and voice, both quavering, both sputtering, both rumbling, are made to tic. Recall that, at the time of her runaway hit single, Jepsen was a twenty-eight-year-old dead ringer for a high school frosh, and was certainly marketed that way. Solarist Projects does not so much defile the "utopian purity" of her sound (in the manner of Tiqqun, who use metaphors to equate critique with acts of violation) as it pushes Jepsen's "pre-sexual chirpiness" to the point of actual warbling.[65] Rendered almost tuneless, Jepsen's new voice is an anxious trilling, her Bécassinian "well . . . I mean . . ." intervening repeatedly midword. "Permanent insecurity," the video declares, again quoting Tiqqun.

Let's return now to the issue of what to do with the voice of the Young-Girl: mash it up and fry it; own, disown, or disavow it; or maybe just fuck 'em all? While Châtelet rejects the girly voice,

64. Jodi Dean, *Blog Theory: Feedback and Capture in the Circuits of Drive* (Cambridge: Polity Press, 2010), 2.

65. Josephine Livingstone, "Grow Up," *New Republic,* June 12, 2017, https://newrepublic.com/article/143249/adult-women-infatuated-teen-age-girls.

Beckles disidentifies with it, and Solarist Projects makes it glitch, *Death and the Jeune-Fille* gives us something different: it stages the question and not the answer. The play is an embodied inquiry into the ownership and dissemination of voices as a fraught process of political subjectivation. In a vertiginous array of operations, actors ventriloquize and parrot each other; repeat each other's lines, but in a staggered loop; interrupt each other and sing in choral harmonies; perform in virtuosic rhythmic synchrony for an exhausting duration; read statements off cards, pointing to each word one by one, but then saying the wrong word; beatbox in rhythm and get overpowered by loud music. If the Young-Girl is an embattled interface between orality and literacy, as we argue earlier in this chapter, then this face at the border between mediums allows political subjects to emerge and also drowns them out.

In the Bureau de L'APA's production, the Young-Girl interface can operate as a *pharmakon,* that is, both toxin and cure, actualizing powers and dangers of the voice that exist in their potential form within *Preliminary Materials.* This function resonates with Marco Deseriis's understanding of the human mic, a practice from leftist protest movements that works "as remedy and poison on direct democracy" by amplifying the voice of the individual in the public sphere (remedy) regardless of the meaning or value of the individual's ideas (poison).[66] Otherwise known as the people's mic and the human microphone, the human mic was practiced by the Occupy movement (2011–12) to contend with laws in New York City preventing the use of amplification in public space. Instead of employing microphones or megaphones to expand the reach of the voice, protesters systematically repeat the words of a speaker in unison. Speeches are broken into small segments for ease of repetition, and usually, each segment is repeated by smaller groups, which vocalize the utterance in waves that ripple across the large

66. Marco Deseriis, "The People's Mic as a Medium in Its Own Right: A Pharmacological Reading," *Communication and Critical/Cultural Studies* 11, no. 1 (2014): 48.

audience. Unlike other kinds of chanting in protests, which focus on short, punchy statements shouted over and over for maximum force and unified energy (consider the call of "no justice!" and the response of "no peace!" repeated for an extended period of time), the human mic is designed to allow entire monologues to be heard, albeit ones that are fragmented and distributed across an audience in stages to facilitate transmission. The human mic gives an individual the volume of a crowd, a political speech the sensuous entreaty of a group chant, and a chorus the imperative to repeat words they as individuals may oppose. This final point is central to the ethics of the human mic.

Deseriis explains the human mic in the same terms as his description of the behavior of the improper name: "the Mic is a con-dividual or trans-individual assemblage of enunciation whereby individual and collective enunciations are intertwined rather than set in opposition to one another."[67] The Bureau de L'APA's peculiar orchestration of speech in *Death and the Jeune-Fille,* though not as formulaic as the human mic (the simplicity of the latter procedure allows it to be performed in a multitude of situations by untrained individuals), likewise productively intertwines individual and collective enunciations. At the same time (and also like the human mic), *Death and the Jeune-Fille* transforms humans into a technology for amplifying the voices of others. Put more positively, we could consider this technology an "instrument of the possibility of a truth not dependent upon intention."[68] This is Gayatri Spivak's description of Echo, that once chatty mountain nymph we discussed in the introduction.

Deseriis's claim that "the embodied, slow-paced and choral nature of the Mic can be seen as an antidote to the speedy and fragmentary nature of online communication" is provocative.[69]

67. Deseriis, 46.
68. Gayatri Chakravorty Spivak, "Echo," *New Literary History* 24, no. 1 (1993): 24.
69. Deseriis, "People's Mic as a Medium in Its Own Right," 42.

However, following his argument about the *pharmakon*, we might consider these attributes of the human mic to catalyze a cure *and* poison already present in networked culture. Articulating a lengthy speech via the human mic is a painfully slow process, as the speaker must fragment an enunciation into segments that can be repeated by the crowd. It can also be considered speedy, though, as the crowd's response to any one of those fragments comes directly after the speaker's call. Thus speech conveyed through the human mic is embodied, slow paced, and choral *as well as* speedy and fragmentary, transforming aspects of networked communication into low-tech, face-to-face address.

The Bureau de L'APA's literalization of *Preliminary Materials* as an acoustic space likewise turns aspects of networked media into face-to-face communication. The power of the play lies in its rhythmic musicalization of the theory of the Young-Girl, recalling Rossana Reguillo's description of the speaker's role in the human mic as that of a "DJ whose art is not just to deliver a musical discourse, but also to know how to interpret the rhythm, the spirit, and the emotions that emanate and that are co-produced by the relationship between the DJ and the people before him or her."[70] Although, at first listen, *Death and the Jeune-Fille*'s approach to musicalization seems more disordered than we hear with the human mic, it rather proposes that the noise of the Young-Girl is simply a more complex and uncomfortable form of order, with the performers' staggered, layered, and often polyrhythmic speech suggesting a collective orchestration of affects. Such organization is maintained not by a conductor but by the performers themselves, with the aid of the Young-Girl interface.

Although *something important happens* when theories of the Young-Girl are spoken aloud, we do not characterize the literalization of the book's acoustic patterning as necessarily subverting

70. Rossana Reguillo, "Human Mic: Technologies for Democracy," *NACLA Report on the Americas* 45, no. 3 (2012): 34.

or resisting the source text. There is no indication that *Death and the Jeune-Fille,* Carlos's video introduction, or Ludd's audiobook intends to critique *Preliminary Materials* at all. Indeed, an examination of the paratextual elements available suggests that these were created in support of Tiqqun's war against the girly face of capitalism (as were Alex McQuilkin's video discussed at the beginning of the book and the "Call Me Maybe" mashup). And Beckles's video may give a sly side-eye to *Preliminary Materials,* but her work does not come off as clearly and entirely against it. Regardless, and most importantly, all four of these outloudings of *Preliminary Materials* respond to a call from within the text that asks for an oral-aural response in return. These responses are not predetermined, although they are made possible by the affordances of *Preliminary Materials* and participate, in varying degrees, in the text's ear-catching, vibratory style. Even the least transformative of these three actions, Ludd's simple shift in modality from a written text to a spoken one, brings something new into being through the decision to divide the text between the voice of advertising and the voice of philosophy.

When we write that *something important happens* in the vocalization of theories of the Young-Girl, what do we mean? Here let's turn to Maurizio Lazzarato's analysis of "The Micro-Politics of Voice and Gesture" from his book *Signs and Machines: Capitalism and the Production of Subjectivity.*[71] Relying on the work of Mikhail Bakhtin, whom Lazzarato praises for "*hear*[ing] voices" as opposed to "*see*[ing] differential relations between signs or between signifiers," Lazzarato identifies the function of the voice in organizing power dynamics.[72] Before speech is concretized into words and sound transmuted into meaning, intonation materializes an "affective and ethico-political" address to the listener.[73] "Only when the voice penetrates and appropriates words and propositions do these

71. Maurizio Lazzarato, *Signs and Machines: Capitalism and the Production of Subjectivity* (Los Angeles, Calif.: Semiotext(e), 2014), 182.

72. Lazzarato, 182.

73. Lazzarato, 183.

latter lose their linguistic potential and transform into an expression that appeals to friends and wards off enemies, that threatens or flatters, repels or pleases, opening to the risk and indetermination of enunciation."[74] The outloudings of *Preliminary Materials* draw the written text into a bold affective and ethico-political stance—*Death and the Jeune-Fille,* for example, through its virtuosic manipulation of vocal rhythms across speech and music, and the audiobook through its surprising choice to alter the voice past ready intelligibility. Both of these theories of the Young-Girl use the paralinguistic aspects of speech to penetrate and appropriate the words and propositions of *Preliminary Materials.*

Importantly, Lazzarato is not lauding this "affective and ethico-political" stance as politically enabling and ethically empowering. Not necessarily. His argument grows out of an analysis of a racist and xenophobic statement made by Nicolas Sarkozy in 2005 in which the presidential hopeful offered to get rid of "scum" *(racaille),* young suburban Parisians, many immigrants of color, who were rioting as a response to police brutality and economic inequities.[75] In his highly politicized impromptu speeches during visits to the Parisian suburbs, Sarkozy referred to cleaning up the *cités* with a pressurized hose—a strategically incendiary allusion to the U.S. police history of hosing antisegregation protesters—and equated the presence of the *racaille* with the graffiti marring the historic white stone of Parisian buildings. As we outline in our article on slam poet Grand Corps Malade's first album *Midi 20* (2006), the term *racaille* comes from the Latin *rasicare, racler, radere,* which evoke the verbs "to scratch" and "to scrape."[76] Laurent Greilsamer links this etymological connection to how the taggers and graffiti artists

74. Lazzarato, 184.

75. INA Société, "Nicolas Sarkozy et les banlieues," YouTube video, 2:21, July 2, 2012, https://www.youtube.com/watch?v=oTtcc5zIrDw.

76. Andrea Jonsson, "Graver le son de l'écriture slam: la voix banlieusarde urbatextuelle dans l'œuvre de Grand Corps Malade," *Modern and Contemporary France* 28, no. 3 (2020): 7.

reappropriated the space by scratching in marks of their belong-ing.[77] The "affective and ethico-political" posture, as Lazzarato puts it, of Sarkozy's condemnation "mobilized [the young residents of the projects] as rebellious, insubordinate, based precisely on their refusal to accept the assignation 'scum.'"[78]

Lazzarato's claims regarding the force of paralinguistics are lever-aged in a broader argument challenging the centrality of the speech act to theories of political subjectivity. Although the notion of the performative was a necessary intervention in the field of linguistics, it should not be as widely applied, Lazzarato insists, as perfor-matives bring *scripted* actions into being and cannot adequately account for political change.[79] Alternatively, the micropolitics of intonation turn an utterance into a truly dialogic and responsive oral-aural event embodying the political potential, for better or for worse, of hearing voices.

Mic Check

Although the human mic was not invented by the Occupy move-ment, it quickly made the practice its own. What started as a way for people to be heard outdoors without microphones or megaphones soon took on an additional function: the disruption of speeches by politicians and other leaders. The exclamation "mic check!" that begins the process of call-and-response for all enactions of the hu-man mic was repurposed as an interruption by guerrilla protesters distributed throughout an audience gathered to hear an official speaker. The Verbi-Voco-Visual performance generally proceeds as

77. Laurent Greilsamer, "Le chiffre et le mot, par Laurent Greilsamer," *Le Monde,* November 7, 2005, https://www.lemonde.fr/idees/arti-cle/2005/11/07/le-chiffre-et-le-mot-par-laurent-greilsamer_707236_3232. html; Sheila Pulham, "Inflammatory Language," *Guardian,* November 8, 2005, https://www.theguardian.com/news/blog/2005/nov/08/inflamma-toryla.

78. Lazzarato, *Signs and Machines,* 183, 175.

79. Lazzarato, 172–77.

follows: When one protester yells out "mic check!" others answer the call with a "mic check!" in response; this exchange is usually repeated. Then a speech is made, part by part, transmitted and amplified via the bodies of the human mic. While other types of human mic favor unscripted speech (or the appearance thereof) broken into short fragments expressed in direct language, thereby easing the process of transmission, the disruptive version of the practice is more open to written text, which allows longer and more complex segments of political speech to be articulated by reading off the page and ensures that if any single caller is removed from the venue, another can take her place and deliver the message. Americans Karl Rove, Newt Gingrich, Barack Obama, Michele Bachmann, and Scott Walker and French former managing director of the International Monetary Fund Christine Lagarde (among others) have all been mic checked, with video documentation circulating on YouTube.[80] The interventionist mic check has expanded beyond the Occupy movement proper, with recent actions by Extinction Rebellion Denver (in an antifracking demonstration), Hydropunk and Take Back the Bronx (at an event in the Bronx hosted by the New Museum), and University of Michigan Law students (at a recruiting event for an international law firm representing ExxonMobil).[81]

Reading off the page while speaking aloud, speaking while listening to others, for a face-to-face audience as well as one watching

80. For example, check out IOccupyFor, "Gov. Scott Walker Gets Checked, Mic Checked!," YouTube video, 3:45, November 4, 2011, https://www.youtube.com/watch?v=1oHRdiklTlU.

81. redtornado, "Fracking Protesters Arrested at State Capital Jan. 9, 2020," *Yellowscene Magazine,* January 11, 2020, https://yellowscene.com/2020/01/11/fracking-protesters-arrested-at-state-capitol-jan-9th-2020/; Hakim Bishara, "A Bronx Event Organized by New Museum Shut Down after Protest by Local Activists," *Hyperallergic,* September 21, 2019, https://hyperallergic.com/518686/a-bronx-event-organized-by-new-museum-shut-down-after-protest-by-local-activists/; Callie Teitelbaum, "University Law Students Protest Paul, Weiss Recruiting Event in Support of #DropExxon Campaign," *Michigan Daily,* February 19, 2020, https://www.michigandaily.com/section/campus-life/exxon-protest.

via social media, *does something* to texts. It transforms the intimate act of reading into collective experiences; opens the private inner voice into public space; transforms subvocal speech into laryngeal phonation, which interacts acoustically with architecture, ambient sound, and other voices; and disassembles and then reassembles voices, in new forms, to be heard from phones and computers, sometimes desynchronized from the movement of mouths due to video playback issues. In the case of the human mic, the intertwinement of individual and collective enunciations is generated, in large part, by the caller/DJ, who sets the rhythm for the crowd as much as she responds to it. Intertwinement here is a back-and-forth call-and-response and a defined rhythmic synchrony, an ordering of voices that operates synecdochally to demonstrate the solidarity and organization of the protesting group.

Rhythmic synchronization is also foregrounded in karaoke videos, which have subtitles that highlight lyrics word by word as the songs unfold so singer-readers can keep time with the music. An artist going by the name of Omsk Social Club feat. PUNK IS DADA makes good use of such subtitles in *Meat Space # My Girlfriend Is the Revolution* (2014), a mesmerizing dance video in which a synthesized masculine voice speaks aloud quotations from *Preliminary Materials,* with the viewer-listener-reader invited to follow the typography on-screen as each word turns from white to magenta, karaoke style.[82] The soundtrack is a dance version of Alphaville's "Forever Young" (1984), slowed down as in chopped-and-screwed remixes, but without the corresponding lowered pitch. As a girlsquad dances in time to the loping 4/4 beat and the crude techno-voice speaks as Tiqqun, the viewer-listener-reader, at least these viewer-listener-readers, taps a foot and synchronizes the voice in her head to the highlighted typography. One of us, a karaoke champ, "sung" along.

82. Omsk Social Club feat. PUNK IS DADA, May 12, 2015, https://punkisdada.tumblr.com/post/118778467347/meat-space-my-girlfriend-is-the-revolution.

For Michel de Certeau, bodily entrainment is the primary prob-
lem with all reading aloud, the dominant (though not exclusive,
as he wrongly assumes) mode of reading prior to the nineteenth
century:

> To read without uttering the words aloud or at least mumbling them
> is a "modern" experience, unknown for millennia. In earlier times,
> the reader interiorized the text; he made his voice the body of the
> other; he was its actor. Today, the text no longer imposes its own
> rhythm on the subject, it no longer manifests itself through the read-
> er's voice.[83]

Silent reading liberates the "actor" from the rhythmic thrall of the
text, claims de Certeau, with clear political implications.

While all language is political, the stakes of our discussion are
higher in regard to speech and text that aim to make the reader
and listener aware of the dynamics of power (however that power
is understood), as liberation, silencing, collective empowerment,
individual freedom, bodily agency, and "having a voice" are often
determining concepts in discourses of political subjectivation. The
presence of the voice in the printed text and the clear articulation
of the text through the voice were especially important to publisher
and polymath Benjamin Franklin, perhaps because of the function
of tone in political satire. Bemoaning the reprinting of his anony-
mously authored "An Edict of the King of Prussia," following then
new typographic conventions, Franklin grumbles to his politician
son in 1773 that it was "stripped of all the capitalling and italicing,
that intimate the allusions and marks [*sic*] the emphasis of written
discourses, to bring them as near as possible to those spoken."[84]
Sixteen years later, he's still fuming about contemporary printed
texts, which hinder the reader's ability "to order the modulation

83. Michel de Certeau, *The Practice of Everyday Life* (Berkeley:
University of California Press, 1984), 175–76.

84. Benjamin Franklin, "To Governor Franklin," in *The Works of
Benjamin Franklin* (Philadelphia: William Duane, 1809), 6:333.

of the voice" appropriately when reading aloud.[85] Franklin makes an interesting case for authorship as an anonymous, faceless, but highly vocal enterprise that turns a reader into a kind of "actor." The question is whether this theatricalization is an invitation to political action or, as de Certeau would hear it, the individual's entrainment to the coercive rhythm of another.

A nostalgia piece from 1921 ("an age of haste," the author sighs dramatically) offers an explicitly depoliticized explanation of the rhythmical "magic of reading aloud."[86] Muriel Harris attempts to revive the Victorian bourgeois practice of reading aloud, especially within the home. "Leisureliness has a measure, a rhythm, while haste stumbles and wastes. . . . And reading aloud had of all things to be leisurely—as leisurely as a patchwork quilt or curtains of the finest netting."[87] Harris credits reading aloud with one's family in the evenings as the primary education for bourgeois women. The association between vocalized reading and feminine domesticity is so strong as to motivate Harris to tout "the transformation of the school into something more like home" as a benefit of the practice in pedagogical settings.[88] Here the haste of silent reading—which de Certeau understands as a kind of freedom—is destructive to rhythm itself, its individualized nature a corruption of the feel-good sociality of the drawing room. Harris's understanding of the kind of homey collectivity engendered through reading aloud is in contrast to another nineteenth-century British textual practice, reading radical periodicals aloud at taprooms and political gatherings. We wonder if any of Harris's Dickens fangirls squee-ing in rapt attention to his latest installment were able to go to bars.

Recalling several modes of collective listening to text, from the overtly political to the nostalgically cozy, YGRG, another response

85. Franklin, "To Noah Webster, Esq.," in *Works of Benjamin Franklin,* 6:238.

86. Muriel Harris, "On Reading Aloud," *North American Review* 214, no. 790 (1921): 348, 347.

87. Harris, 348.

88. Harris, 351.

to *Preliminary Materials,* stages events in which performers read books aloud. A performance series created by Polish artist Dorota Gawęda and Lithuanian artist Eglė Kulbokaitė, YGRG began in 2013 in Berlin as a weekly reading group, for which the first text was Reines's translation of *Preliminary Materials.* Since, Gawęda and Kulbokaitė have mounted numerous performances riffing on the format of the reading group in increasing complexity, in galleries in London; in Brooklyn, New York; in Rio de Janeiro; and throughout Eastern and Western Europe, especially in Germany. A press release, most likely written by the artists themselves, describes the series in the following manner:

> Young Girl Reading Group investigates the act of reading as inti-
> mate experience, holding the potentiality to become public through
> the "outlouding" of words, otherwise under-emphasized. In corre-
> spondence with Tiqqun's *Preliminary Materials For a Theory of the
> Young-Girl,* organized around feminist thought both historical and
> contemporary, and inspired by theory and fiction, YGRG provides an
> intimate discursive space within the experience of collective reading.[89]

Prioritizing feminist and queer theory as well as science fic-
tion, YGRG has outlouded texts by Sara Ahmed, Rosi Braidotti, Octavia Butler, Sylvia Federici, Zakiya Hanafi, Donna Haraway, Luce Irigaray, Hao Jinfang, Ursula K. Le Guin, Lynn Margulis and Dorion Sagan, Paul B. Preciado, and many others. "The individu-
ated texts we choose become filaments of infinitely tangled webs," the artists explain.[90]

The current format of the events involves performers of all gen-
ders adopting a series of poses, positioned in an art installation involving flat-screen monitors or video projections and other ele-
ments (sometimes quite involved, such as piles of rotting grass or

89. "Young Girl Reading Group: Coming of Age," *Art in General,* https://www.artingeneral.org/exhibitions/671.
90. Qtd. in River Young, "Manifesting Young-Girl Reading Group," August 14, 2015, https://www.aqnb.com/2015/08/14/manifest-ing-young-girl-reading-group/.

hundreds of pounds of rust-brown powder arranged in mounds), while reading sections of texts aloud, usually off cell phones (in a performance in London in 2016, "zip-ties were used to fix digital reading devices onto performer's [*sic*] bodies and also onto the bodies of some audience members," writes Hannah Nussbaum).[91] The events are simultaneously live streamed. "The performers lounge around reading from their phones, transmitting performances through Instagram stories—just like us in our bedrooms," as critic Anastasiia Fedorova describes.[92] YGRG also runs an active Facebook page, currently comprising more than thirty-seven hundred members, on which the artists post invitations to their performances, calls for submissions for art exhibitions, and news articles about environmental issues, human rights violations, and the activism of feminists of color around the world, among other topics.

Gawęda and Kulbokaitė frequently frame their practice as playing with the boundary between the private and the public. They use cell phones in their performances because "the phone gives you a feeling of safety and familiarity," like the bourgeois drawing room as Harris experienced it, we might add. "It makes you feel like you are in your own space, although actually, it's the opposite."[93] Semi-reclining and propped up on elbows, leaning wanly against each other, or lying on stomachs with legs in the air, performers read aloud in postures suggestive of teenage slumber parties, reminding us of Tiqqun's insistence that "the supposed liberation of women did not consist in their emancipation from the domestic sphere, but rather in the total extension of the domestic into all of society."[94] Indeed, although the artists often explain their work as turning the

91. Hannah Nussbaum, "A Techno-Feminist Reading List," *Tank Magazine,* November 2017, https://tankmagazine.com/tank/2017/11/young-girl-reading-group/.

92. Anastasiia Fedorova, "Young Girl Reading Group: Preliminary Materials for the Future," *Perfect Number Mag,* July 15, 2019, https://mag.perfectnumber.co/young-girl-reading-group-preliminary-materials-for-the-future/.

93. Gawęda qtd. in Fedorova.

94. Tiqqun, *Preliminary Materials,* 43.

private into the public, we could also understand it as turning the public into the private. More specifically, the choreography recalls bodies chilling in the private space of the "boudoir" ("a space which enclosed both female reading and female sexuality," as Gawęda puts it), boudoirizing the gallery, while the collective outlouding of texts reanimates Harris's homey, classed vision of girls' educational experiences in the nineteenth-century drawing room, but as a newly politicized and self-aware form of leisure.[95]

Gawęda and Kulbokaitė have an admittedly "uneasy relation" with the Young-Girl whose girl power, McKenzie Wark explains, has turned "life in the overdeveloped world" into "a social boudoir."[96] Their discomfort "triggers the need to commit to YGRG as a space for conversation."[97] This articulation of the goal of YGRG is from a 2015 email interview in which the artists adopt the now familiar practice of aping aspects of *Preliminary Materials,* in this case, the manifesto's epigraph from *Hamlet* and the first three chapter titles. Their "manifesto" interweaves quotations from *Preliminary Materials* with quotations from *critiques* of *Preliminary Materials* and references to other works of theory, incorporating into the fragmented body of the text the tools of its own undoing.[98] Out of "a hyperlink-heavy selection of quotes, references, aphorisms and assertions, which at times read like concrete poetry, at others, a comment feed on social media," as interviewer River Young describes it, emerges the artists' assertion that "the Young-Girl here is the one who's acting."[99]

What does it mean for the Young-Girl to act? In the case of YGRG, it is "about listening to each other—while reading."[100] YGRG explicitly configure the aurality of their performances as the largest part of

95. Gawęda qtd. in Fedorova, "Young Girl Reading Group."
96. Qtd. in Young, "Manifesting Young-Girl Reading Group";
McKenzie Wark, *The Spectacle of Disintegration* (London: Verso, 2013), 198.
97. Qtd. in Young, "Manifesting Young-Girl Reading Group."
98. Young.
99. Young.
100. Julia Moritz, "P.S. YGRG #96," Kunsthalle Zurich, September 30, 2015, http://kunsthallezurich.ch/en/articles/ps-ygrg-96.

a broader feminist enterprise to reorganize the senses without the patriarchal dominance of vision, empowering hearing, touch, and even smell. Sometimes YGRG works with signature scents, such as for the performance *YGRG154: Body Heat* at the Amanda Wilkinson Gallery in London, featuring sections from Richard Sennett's *Flesh and Stone: The Body and the City in Western Civilization* (1994), among other texts. "Throughout the performance and exhibition an aroma-diffuser releases a scent that the artists commissioned from the parfumier Caroline Dumur at IFF Inc. Her brief was to create a smell that embodies the concept of the Young-Girl."[101] The effect of the perfume and its intermingling with the smell of bodies was likely amplified by heat lamps positioned over the readers. YGRG aim to create total experiences; McLuhan, whose book *The Gutenberg Galaxy* is referenced in an interview with YGRG, explains that "oral means 'total' primarily, 'spoken' accidentally."[102]

Another response to *Preliminary Materials* also aims to reorient our sensory experience, turning away from an ocularcentric understanding of the Young-Girl as either object or subject of the gaze and instead foregrounding the affective charge created by the convergence of sense perception. *Bubble Boom, the Jeune-Fille said: a bit of bubble and a little bit of boom* by Lopez and René-Worms has a live element in addition to the poetry we previously discussed. For the performance, spectators milled about, drank special cocktails, and smelled "an acidulous and repellent perfume" (a sister scent, perhaps, of the Young-Girl/Man-Child's rotting butter, discussed in the previous chapter), while performers whispered quotations from *Preliminary Materials* into their ears, chewed pink gum, and blew bubbles.[103] The intimate proximity of the whispering perform-

101. Press release, Amanda Wilkinson Gallery, https://amandawilkin-songallery.com/usr/documents/exhibitions/press_release_url/69/ygrg-pr.pdf.

102. Gawęda et al., "Young-Girl Reading Group"; Marshall McLuhan, "Brainstorming: The Strange Case of Minerva's Howl," in *Verbi-Voco-Visual Explorations*.

103. "Bubble Boom," *Rafaela Lopez,* https://rafaelalopez.net/Bubble-Boom.

ers to the bodies of the audience extended the sensorial reach of quiet speech; we assume that the hot breath of the speaker could be felt by the listener. The sweet smell of the gum mixed with the offensive perfume and the performers' personal scent, no doubt (gum and perfume also feature prominently in Beckles's *Theory of the Young Girl*).

Lopez and René-Worms's remixed theory of the Young-Girl moved through the crowd like a pathogen (language is a virus, sings Laurie Anderson after Burroughs, though not after COVID-19). It spread through a cloud of intoxication and sweet acridity, like small-town gossip, like salacious social media chitchat. The circulatory behavior of this theory mediatized performers and audience in the convergence culture of the gallery space, recalling Henry Jenkins's argument regarding "the flow of content across multiple media platforms, the cooperation between multiple media industries, and the migratory behavior of media audiences who will go almost anywhere in search of the kinds of entertainment experiences they want."[104] "Bubble gum is whispered and penetrates the body / Perfume and bitterness," explains the poem.[105] Lopez and René-Worms's performance emphasized the synaesthetic possibilities of the age of bell(es). The Young-Girl is an oral fixation that simultaneously fascinates and offends, and the gallery public was invited to become what Grant McCracken calls, not consumers, but "multipliers," participants who spread the word.[106]

Gum chewing has long been associated with youthful loitering and boredom. Moon Unit Zappa's older male interviewer finds the wad of gum pressing against the inside of the Valley Girl's cheek uncomfortably funny, while the Young-Girl's gum chewing would

104. Henry Jenkins, *Convergence Culture: Where Old and New Media Collide* (New York: New York University Press, 2006), 2.

105. "Bubble Boom."

106. Grant McCracken, "'Consumers' or 'Multipliers,'" *Spreadable Media,* https://spreadablemedia.org/essays/mccracken/index.html#. XyOZIiHPzOQ.

certainly annoy and affront Tiqqun.[107] Just as chewing gum is performing an essential task without producing its original effect—we usually masticate to break down our food better for the extraction of nutrients—the language that Tiqqun attribute to the Young-Girl "is not made to talk with, but rather to please and to repeat."[108] If the Young-Girl's language is more like filling a chewable substance with air than creating meaning through the semantic, it has nevertheless figured out affective and paralinguistic ways to assure its spread. "I have come here to chew bubblegum and kick ass, and I'm all out of bubblegum." So goes the iconic one-liner from John Carpenter's anticapitalist opus *They Live* (1988).[109] The Young-Girl always has gum and is never allowed to kick ass, although she is, like the last name of *They Live*'s hero, Nada. There's an old wives' tale that swallowed gum stays lodged inside the body for seven years.

Bubble Boom, the Jeune-Fille said exploits multiple modes of bodily infiltration through taste, smell, touch, and sound. YGRG events also use the total sensory experience, reconfigured through the dehierarchizing power of orality, to produce a situation that amplifies an awareness of the permeability of bodies. Olfaction is important because smell is, for them, *"a performative play on the molecular level that highlights the breaking boundaries between us, the other and nature, flowing through and across humans and machines, life-forms and non-life-forms."*[110]

This "vulnerable hyperbody" generated through their performances is one of "particles and molecules that circulate within," they write, as well as "prefaces," "citations," and "appendices."[111]

107. Thompson, "Moon Unit Zappa Full Show."

108. Tiqqun, *Preliminary Materials,* 25.

109. Movieclips, "They Live (1988)—Here to Chew Bubblegum and Kick Ass Scene (4/10) Movieclips," YouTube video, 2:16, August 26, 2019, https://www.youtube.com/watch?v=Du5YK5FnyF4.

110. Ella Plevin, "Dorota Gawęda and Eglė Kulbokaitė at Futura," *Art Viewer,* October 28, 2019, https://artviewer.org/dorota-gaweda-and-egle-kulbokaite-at-futura/.

111. Gawęda et al., "Young-Girl Reading Group."

Their theory of the Young-Girl gives text a material granularity and smell a citational force in the read-writing of collective bodies.

The artists insist that "the porosity of a queer reading enables us to observe the constellations of history as engulfed in capital and governed by an invisible grid of regulated spaces, actual and virtual like."[112] Perhaps surprisingly, their critique of capitalism comes alongside an embrace of the commodity form: the perfume used for *YGRG 154: Body Heat* was sold at a YGRG Outlet alongside branded clothing as part of the exhibition *YGRG 14X: reading with a single hand* at Cell Project Space in London. According to the press release for the YGRG Outlet, "the store represents a branded material collapse of production into a gesture of social performativity using their recently patented fragrance *BODY AI,* newly commissioned limited editions and sportswear line. In the same way as the artists' social media interventions, their branded unisex YGRG T-shirts and sweatshirts orientate their activities around collectivity and peer-to-peer circulation."[113] It is unclear if this is irony. We recall Julian Hanna's words on the form of the manifesto: "the manifesto, which has long borrowed from advertising, has itself been coopted as a business-friendly genre. It has of late become tame, even cute: an untroubling, unironic, fully digested meme for the attention deficient."[114] If, indeed, "the Young-Girl here is the one who's acting," then whose rhythms is she performing, who is the desired audience, and who, if anyone, is winking?[115] A network of etymological affil-

112. Dorota Gawęda and Eglė Kulbokaitė qtd. in Lewon Heublein, "Permeable Screens: The Young-Girl Reading Group," *PW Magazine,* June 12, 2019, https://www.pw-magazine.com/2019/permeable-screens-the-young-girl-reading-group/.

113. "YGRG Outlet: Eglė Kulbokaitė and Dorota Gawęda," *Cell Project Space,* https://www.cellprojects.org/events/ygrg-outlet.

114. Julian Hanna, "Manifestos: A Manifesto," *Atlantic,* June 24, 2014, https://www.theatlantic.com/entertainment/archive/2014/06/manifestos-a-manifesto-the-10-things-all-manifestos-need/372135/.

115. Young, "Manifesting Young-Girl Reading Group."

iations ties together chant, enchanting, secret language, insincere talk, "the whining or singsong tone of a beggar."[116]

Through performances of reading and writing—YGRG write extensively about their own practice, actively constructing the critical context for their production—Gawęda and Kulbokaitė purvey "intimate publicity" from within the perfumed boudoir of the Young-Girl.[117] They have an "uneasy relation" with her, although she "gives the name to our project and opens up to the problematic networks of ideas to be discussed."[118] YGRG poses several compelling questions, questions with which we have an uneasy relation. How can we engage the powerful feelings of totality and integration that pervade digitally enabled acoustic space? How can we simultaneously reject the totalizing and integrative power of the Spectacle ("oral means 'total' primarily, 'spoken' accidentally")?[119] How can we resist the multisensuous demands of communicative capitalism, given the vulnerability of our bodies? At the same time, how can we commit to that resistance without losing vulnerability itself as an embodied communicative capacity?

116. *Dictionary*, s.v. "cant," https://www.dictionary.com/browse/cant?s=t.

117. Heublein, "Permeable Screens."

118. Qtd. in Young, "Manifesting Young-Girl Reading Group."

119. McLuhan, "Brainstorming."

3. Conclusion, or Fucking Up

The Young-Girl's laughter rings with the desolation
of nightclubs.

—TIQQUN, *Preliminary Materials for a Theory of the
Young-Girl*

Well . . . I mean . . .

—THE BÉCASSINES FROM GILLES CHÂTELET, *To Live and
Think Like Pigs*

Of Medusas, Vampires, and Nymphs

In her video *Tahrïk* (*Diacritics,* 2018), Lebanese artist Nesrine Khodr
reads aloud off wrinkled paper she holds in her hand. In preparation
for the piece, she compiled sections from three texts—*Preliminary
Materials* (part of the chapter "The Young-Girl as Phenomenon"),
Hélène Cixous's "The Laugh of the Medusa" (1975/1976), and Iman
Mersal's "On Motherhood and Violence" (2015). All are in Modern
Standard Arabic (or MSA, also called Fus'ha), the first two in trans-
lation. MSA is the transnational version of Arabic used in formal
written communication and in television news and radio reports
across the Arab world. Everyday spoken communication occurs us-
ing regional Arabic dialects that often differ considerably from each
other and from MSA. Khodr's video addresses one of the challenges
of MSA: short vowels are not written, and the reader must thus add
them based on her knowledge of the language. A mistake might re-
sult in a grammatical error or semantic confusion. Alternatively, it
could simply be "sonorically dissonant to the learned ear," explains

the artist.[1] Khodr courts such mistakes in *Tahrïk*. She begins by reading aloud to an unseen but audible audience that corrects her errors when they occur. She then starts fucking up on purpose, and soon the audience participates in a gloriously uncontrolled vowel fest that "becomes like a free composition."[2] We hear iterated versions of the same word but with different vowels, from both her and her listeners. The through line of the text turns into an unhinged melisma. She concludes the piece by articulating the vowels correctly, in a sober denouement.

Khodr chose the three texts because of their "disruptive nature," she explains.[3] *Preliminary Materials,* which hadn't, to her knowledge, been previously translated into Arabic, attracted her because of the "way the text was written in addition to its content, the subversive tone, the layout of the text, the form in which this content was presented, the way it was composed of fragments."[4] In the terms we've used throughout this book, Khodr responds to a call from within the text itself, and that call is primarily formal and affective. Her response is to vocalize. She then elicits additional oral responses from others—the audience outside of the camera's visual reach, who participate in a collective improvisation of freewheeling vowel iteration. Khodr's particular performance of outlouding gives a unique frame to the notion of the Young-Girl as a charged interface between written and spoken modes of communication, an idea developed in the previous chapter, and to the "unseemly, confused stammering" of Châtelet's Bécassines and Naomi Wolf's vocal fryers.[5]

At roughly the nine-minute mark of the almost-sixteen-minute video, Khodr abruptly breathes in, stops speaking, and smiles broad-

1. Nesrine Khodr, email correspondence, June 10, 2020.
2. Khodr.
3. Nesrine Khodr, email correspondence, January 31, 2019.
4. Khodr.
5. Châtelet, *To Live and Think Like Pigs,* 102; Wolf, "Young Women, Give Up the Vocal Fry."

ly, her gaze continuously fixed on the paper. A sonic disruption, someone in the audience knocking something over perhaps, temporarily throws her off her game. The paper trembles; she looks like she's playfully stifling a laugh, and when she returns to speaking, she has a joyful, vibratory energy. This moment of bodily irruption—which appears unplanned in a performance of straight-faced decorum, one that was filmed in a single take—recalls Cixous's "The Laugh of the Medusa." This is an essay full of references to sound. The medusal laugh is a demand for *écriture féminine* as an irruptive and disruptive embodied practice of writing that retains the musicality of the mother's tongue.[6] Khodr's silent smile is not what Cixous had in mind, and Tiqqun's text would most certainly have turned the French feminist to stone. However, the wide opening of Khodr's mouth transducing the force of laughter into a vocal vibe of pleasure—the jubilance of fucking up, the jubilance of vowels gone rogue in surround sound—would likely have made Cixous smile in response. Khodr's almost laughter is laughter I can *feel*. "One incants laughter, in the same way one incants the name of a god, in the hope that, through repetition, laughter can magically be brought into the present of the incantator," writes philosopher Anca Parvulescu.[7]

In this book, we argue that the style of *Preliminary Materials*—its affective rhythms, aesthetic of fragmentation, iterative approach to rhetoric, and animating aural address—is a call demanding a response. One of these wide-ranging reactions, *Tahrïk* offers its own performance of call-and-response as a mise-en-abyme of the broader field of Young-Girl theories. This "re-versioning relay," to borrow Charlotte Frost's phrase for communication via LISTSERVs, begins as a series of corrections and then turns into pronunciation gone wild.[8] When the audience stops disciplining Khodr's voice

6. Hélène Cixous, "The Laugh of the Medusa," *Signs* 1, no. 4 (1976): 875–93.

7. Anca Parvulescu, *Laughter: Notes on a Passion* (Cambridge, Mass.: MIT Press, 2010), 2.

8. Frost, *Art Criticism Online*, 106.

and commits to fucking up together, we hear a "sonorically disso-
nant" kind of music. Fucking up together is different from fucking
someone over. This is as good a time as any to say that Jere on
Goodreads gives *Preliminary Materials* four out of five stars. Jere
pulls out the following quotation to support the rating: "It wasn't
until the Young-Girl appeared that one could concretely experience
what it means to 'fuck,' that is, to fuck someone without fucking
anyone in particular. Because to fuck a being that is so really ab-
stract, so utterly interchangeable, is to fuck in the absolute."[9] It is
unclear if the reviewer means to praise this theory of fucking or if
this is why Jere knocks off a star.

References to *Preliminary Materials* keep coming, and we wor-
ry we will fuck it all up either by neglecting to include them or
failing to complete this book. We really feel Jodi Dean's cranky
complaint, in her book on blogging and communicative capitalism,
that "to address its object in a timely fashion, the book has to be
new, fresh, up-to-the-minute, fashion forward, bleeding edge. . . .
The book is pushed to adopt, in other words, the entrepreneurial
expectations of the venture capitalist, racing to be the first out of the
block."[10] One of these fresher references is from Paul B. Preciado
(incidentally, whose book *Testo Junkie: Sex, Drugs, and Biopolitics
in the Pharmacopornographic Era* was read, in part, at some YGRG
events). Preciado briefly turns to Tiqqun in "On the Verge" (2020),
an essay that gives a name to recent global protests against racism,
police brutality, misogyny, sexual violence, and other forms of op-
pression: the name is "revolution."[11] In the essay's introduction,
Tiqqun's insistence on including "Marais homos" and *beurettes* in
the category of Young-Girl gets a parenthetical exclamation—"(how

9. Jere, review of *Preliminary Materials for a Theory of the Young-
Girl* by Tiqqun, Goodreads, February 2, 2015, https://www.goodreads.com/
en/book/show/14367458-preliminary-materials-for-a-theory-of-the-young-
girl.

10. Dean, *Blog Theory*, 2.

11. Paul B. Preciado, "On the Verge," *Artforum*, July/August 2020, 95.

to even envision the displacement between these figures without falling into homophobia and racism!)."[12] Preciado's essay does not present Tiqqun as clairaudient soothsayers who heard our current era way back in 1999, despite this tendency among responses to *Preliminary Materials*. "Our Tiqqun friends" who held out no hope for the Young-Girl, Preciado writes, "did not predict that it would be precisely these groups—the young girls, the gays, the trans people, and the racialized denizens of the banlieue—that would lead the next revolution."[13] Understanding the Young-Girl as degendered, desexed, and deracinated likely means falling into homophobia and racism, and yet the fraught conceptual category Tiqqun participate in assembling has, for Preciado, held together, as something and not nothing, at least well enough to reemerge in summer 2020 in an essay about synchronized dissidence.

While fucking the rhetorical figure of the Young-Girl may be fucking no one in particular, as Tiqqun whimper, their theory at its best (and maybe against our better judgment, to add another parenthetical) might be made to describe a collective of the anyone-seriously-fucked-over. In calling this collective the Young-Girl, though, Tiqqun fail to reckon with the multifarious and uncategorizable power of the "somatopolitical alliance" their theory might have imagined if it weren't so invested in girliness as an index of political failure.[14] We might consider this work of imagining differently as the compositional and performative effort of Tiqqun's more hopeful reader-listeners. We are reminded of McLuhan's contention that the "sudden implosion" that produced the global village "alters the position of the Negro, the teen-ager, and some other groups. They can no longer be *contained*, in the political sense of limited association. They are now *involved* in our lives, as we in theirs, thanks to the electric media."[15] This (racist) attempt to cleave the "we" from

12. Tiqqun, *Preliminary Materials*, 15; Preciado, "On the Verge," 95.

13. Preciado, "On the Verge," 95.

14. Preciado, 101.

15. Marshall McLuhan, *Understanding Media: The Extensions of Man* (Cambridge, Mass.: MIT Press, 1994), 5.

the "they," a rhetorical move so familiar to readers of *Preliminary Materials,* can be heard as a delightfully botched warning: a new somatopolitical alliance has assembled, and they/we walk among them/us. Fuck you, McLuhan, but also, *bisous* ("thanks to the electric media," Echo repeats with a smile).

Preciado's "On the Verge" is occasioned by an urgent need to register the impact of COVID-19 on the revolutionary somatopolitical alliance forged before "our strategies for fighting were decollectivized and our voices fragmented" by global quarantine measures.[16] Although the bulk of the essay was written in April 2020, when Preciado was most hopeless about the viability of face-to-face political protest, he offers an optimistic coda written on June 4, two days after a Parisian Black Lives Matter protest demanding accountability for the murder of Adama Traoré by three police officers during a 2016 arrest outside of Paris. In an article in the *New Yorker,* Traoré's sister Assa Traoré attributes the broad participation in the march to the powerful reverberation between the fury over her brother's murder and the outrage over the asphyxiation of African American George Floyd. "The two fights echo each other, so that we're pulling back the curtain on France, in saying, 'People of the whole word [*sic*], look what's happening here.'"[17] She demands that those listening to her become spokespeople forcing France to confront its colonial past and the toxic color-blindness of the *République,* calling herself a soldier leading a "machine of war."[18] Assa Traoré is not what Tiqqun have in mind when they personify the "war machine" through the compliant commodified body of their Young-Girl.[19] Indeed, Assa Traoré gives us the obverse of "the Young-Girl X, the Young-Girl Y, the Young-Girl Z" with her algo-

16. Preciado, "On the Verge," 96.

17. Qtd. in Lauren Collins, "Assa Traoré and the Fight for Black Lives in France," *New Yorker,* June 18, 2020, https://www.newyorker.com/news/letter-from-europe/assa-traore-and-the-fight-for-black-lives-in-france.

18. Collins.

19. Tiqqun, *Preliminary Materials,* 105.

rithmic chant of "we fight for Adama, we fight for Ibrahima Bah, we fight for Gaye Camara . . . the list is too long!" ("On se bat pour X . . . la liste est trop longue"), transforming the serial oral-aural rhythms particular to the Young-Girl's brutal generation into an iterative, energetic, ever-expanding care for the accruing victims of brutality around the world.[20] Preciado notes that the Parisian activists were mostly younger than thirty years old.[21] Although his essay does not mention Tiqqun after its introduction, the return to youth in the essay's coda embraces the political potential of the market segment whose *"Youthitude"* was dispossessed and redistributed in the extractivist process of "Young-Girlist formatting."[22] The question is whether it is only capitalism responsible for such vampirism or if *Preliminary Materials* is political theory's own Vlad Dracula. It is said that vampires can perform a kind of echolocation, and that they have hearts that beat, albeit slowly.[23]

It has been tempting to perform an auscultation on theories of the Young-Girl, including Tiqqun's. To diagnose, once and for all, their misogyny or feminism. To listen for the arrhythmias at the center of fourth-wave feminism or capitalist oppression or mass consumption or neoliberalism. To determine who or what is fucking over the Young-Girl or whether someone's fucking with us. *Young-Girls in Echoland* is not that book (and perhaps we're fucked-up feminists). Our style of close listening cannot identify causes.

In "Close but Not Deep: Literary Ethics and the Descriptive Turn," Heather Love critiques the analytical approach that con-

20. Révolution Permanente, "Discours poignant d'Assa Traoré. Justice pour Adama, George Floyd et toute victime de la police," YouTube video, 22:24, June 2, 2020, https://www.youtube.com/watch?v=l_VZBiRnGcI.

21. Preciado, "On the Verge," 101.

22. Tiqqun, *Preliminary Materials*, 16, 19.

23. "Biology of a Vampire," *Angelfire*, http://www.angelfire.com/goth2/vampirestudies/biology.html/#:~:text=Vampire%20Blood%3A&text=Living-born%20vampires%20maintain%20a,that%20the%20body%20may%20function.

tinues to dominate literary studies (and, we would add, all of the humanities), the hermeneutics of depth. She explains that "the 'depth' of 'depth hermeneutics' should be understood not only as the hidden structures or causes that suspicious critics reveal. Depth is also a dimension that critics attempt to produce in their readings, by attributing life, richness, warmth, and voice to texts."[24] While Love advocates reading closely but not deeply as a turn to "the thin and the dead," our tactic has been to apprehend, in theories of the Young-Girl, a different kind of life, a different kind of voice, a noisy, pulsing animation born of the movement and confused transformation of ideas, facilitated by the very instability, ambiguity, and utter shittiness of the Young-Girl as a conceptual persona.[25] This different kind of life is also a different aesthetic and calls out for a kind of theory that foregrounds its stylistic gestures, that is, its aesthetico-affective-political stance. The Young-Girl has become a pop theory phenomenon appealing to artists, poets, directors, actors, musicians, anarchists, and communists in part because it is stylish and invites others to be unabashedly stylish in response.

"Taking leave of all goodwill, he proposes in a vigorous style to mobilise thought."[26] This is Christine Goémé on Gilles Châtelet's *To Live and Think Like Pigs*. Style, for Châtelet, is philosophy's true and serious business, "an entirely integral part of thought qua *thought experiment*." "Style is a discipline of breaking language out of itself, a martial art of metaphor."[27] The style of *Preliminary Materials* is more problematic but equally vigorous, mobilizing thought across time, space, medium, and political affiliation. Language is broken, but through less discipline, more teenage riot.

Preliminary Materials for a Theory of the Big-Eyed-Orphan, Preliminary Materials for a Theory of the Mass-Ornament,

24. Heather Love, "Close but Not Deep: Literary Ethics and the Descriptive Turn," *New Literary History* 41, no. 2 (2010): 388.

25. Love, 388.

26. Châtelet, "A Martial Art of Metaphor."

27. Châtelet.

Preliminary Materials for a Theory of the Nana-Jaseuse, Preliminary Materials for a Theory of the Pissy-Rivulet, Preliminary Materials for a Theory of the Noxious-Gas, Preliminary Materials for a Theory of the Red-Pill, Preliminary Materials for a Theory of the Mechanical-Bride, Preliminary Materials for a Theory of the Belle-Age, Preliminary Materials for a Theory of the Nymphe-Résonante, Preliminary Materials for a Theory of the Scalar-Power, Preliminary Materials for a Theory of the Sexxxy-Minitel, Preliminary Materials for a Theory of the Algorithmic-Chant, Preliminary Materials for a Theory of the Double-Dutch, Preliminary Materials for a Theory of the Dark-Lord, Preliminary Materials for a Theory of the Computational-Generator, Preliminary Materials for a Theory of the Rotten-Butter, Preliminary Materials for a Theory of the Mannequin-Instant, Preliminary Materials for a Theory of the Anonymous-Mask, Preliminary Materials for a Theory of the Meuf-Militante, Preliminary Materials for a Theory of the Dominant-Matrix, Preliminary Materials for a Theory of the Growling-Undercurrent, Preliminary Materials for a Theory of the Ragged-Rage, Preliminary Materials for a Theory of the Cosmopolitan-Operation, Preliminary Materials for a Theory of the Britney-Kardashian, Preliminary Materials for a Theory of the Improper-Ludd, Preliminary Materials for a Theory of the Digital-Hamster, Preliminary Materials for a Theory of the Noncommittal-Tweet, Preliminary Materials for a Theory of the Miami-Dolphin, Preliminary Materials for a Theory of the Dickens-Fangirl, Preliminary Materials for a Theory of the Public-Boudoir, Preliminary Materials for a Theory of the Chuchotement-Mélodique, Preliminary Materials for a Theory of the Spoken-Total, Preliminary Materials for a Theory of the Son-Spiral, Preliminary Materials for a Theory of the Chewing-Multiplier, Preliminary Materials for a Theory of the Bulle-Glacée, Preliminary Materials for a Theory of the Singsong-Tone, Preliminary Materials for a Theory of the Desolate-Laughter, Preliminary Materials for a Theory of the Vivace-Salée, Preliminary Materials for a Theory of the Stylish-Pig, Preliminary Materials for a Theory of the Revolutionary-Alliance.

sk[28]

Well . . . I mean . . . fuck girlphobia.

28. *Urban Dictionary*, s.v. "Vsco Girl," https://www.urbandictionary.com/define.php?term=VSCO%20GIRL.

Acknowledgments

This project evolved over the course of several years. At first, it was a solo project, an extension of Heather Warren-Crow's *Girlhood and the Plastic Image* (2014) and "Gossip Girl Goes to the Gallery: Bernadette Corporation and Digitextuality" (*Performance Research* 18, no. 5 [2013]). Then it became a duet, thanks to the support of a fellowship from the Humanities Center at Texas Tech University. This collaboration took the authors down a Franco-American path of two moms (re)living the complexities of girlhood while going to bat for Young-Girls. Ideas matured over mini milkshakes at J&B Coffee and mini prosecco bottles, long walks, food adventures, and backyard dance parties. Drafts emerged and were mixed, sampled, and echoed. It has been an unforgettable experience to find the points of interdisciplinary intersection and to test out and orchestrate ideas in ensemble.

The authors thank the following artists for their private correspondence and the access they gave to archival materials: Madelyne Beckles, Jennifer Boyd, Laurence Brunelle-Côté, Judith Cahen, Olivier Choinière, Simon Drouin, Nesrine Khodr, Alex McQuilkin, and Stacey Teague. Many thanks go to generous reviewer Andrea Righi and especially our stalwart editor, Eric Lundgren, both of whom made suggestions that shaped the final document.

Drea would first and foremost like to send her deepest gratitude to Heather for her intellectual generosity and mentorship. She

thanks the Women's Faculty Writing Program and the Department of Classical and Modern Languages and Literatures at Texas Tech University and the School of Modern Languages at the Georgia Institute of Technology. Special thanks to her family for their support.

As always, Heather is grateful for her partner, Seth Warren-Crow, for such close listening to the soundscape of their world. It's a banger with a beat you can dance to.

(Continued from page iii)

Forerunners: Ideas First

P. David Marshall
The Celebrity Persona Pandemic

Davide Panagia
Ten Theses for an Aesthetics of Politics

David Golumbia
The Politics of Bitcoin: Software as Right-Wing Extremism

Sohail Daulatzai
Fifty Years of *The Battle of Algiers*: Past as Prologue

Gary Hall
The Uberfication of the University

Mark Jarzombek
Digital Stockholm Syndrome in the Post-Ontological Age

N. Adriana Knouf
How Noise Matters to Finance

Andrew Culp
Dark Deleuze

Akira Mizuta Lippit
**Cinema without Reflection: Jacques Derrida's
Echopoiesis and Narcissism Adrift**

Sharon Sliwinski
Mandela's Dark Years: A Political Theory of Dreaming

Grant Farred
Martin Heidegger Saved My Life

Ian Bogost
The Geek's Chihuahua: Living with Apple

Shannon Mattern
Deep Mapping the Media City

Steven Shaviro
No Speed Limit: Three Essays on Accelerationism

Jussi Parikka
The Anthrobscene

Reinhold Martin
Mediators: Aesthetics, Politics, and the City

John Hartigan Jr.
Aesop's Anthropology: A Multispecies Approach

Heather Warren-Crow is associate professor of interdisciplinary arts at Texas Tech University. She is the author of *Girlhood and the Plastic Image* (2014).

Andrea Jonsson is assistant professor of French at the Georgia Institute of Technology.